IMAGES
of America

GREENSBORO'S
FIRST PRESBYTERIAN
CHURCH CEMETERY

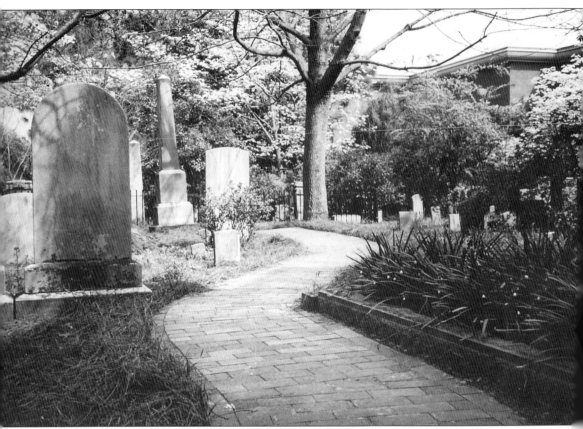

There are many pleasures to be experienced with a stroll through time in Greensboro's 19th-century cemetery. It is a living outdoor museum of sculpture detailing the lives of the early citizens of Greensboro as told by the weathered inscriptions carved on the tombstones. The cemetery was used as a church, public, and family burial ground in the early days. Today it is an insightful gift from the people of the 19th century to the people of today and future generations.

ON THE COVER: The First Presbyterian Church Cemetery, located behind the Greensboro Historical Museum at 130 Summit Avenue in Greensboro, North Carolina, provides visitors with the unique experience of visiting the burial location of several of the early citizens of Greensboro.

IMAGES
of America

GREENSBORO'S
FIRST PRESBYTERIAN
CHURCH CEMETERY

Carol Moore

ARCADIA
PUBLISHING

Published by Arcadia Publishing
Charleston SC, Chicago IL, Portsmouth NH, San Francisco CA

Printed in the United States of America

Library of Congress Catalog Card Number: 2006926063

For all general information contact Arcadia Publishing at:
Telephone 843-853-2070
Fax 843-853-0044
E-mail sales@arcadiapublishing.com
For customer service and orders:
Toll-Free 1-888-313-2665

Visit us on the Internet at www.arcadiapublishing.com

This book is dedicated to the memory of the sainted dead who are interred in the First Presbyterian Church Cemetery and to all the people past and present who have taken a loving interest in preserving the old cemetery as a gift to future generations.

CONTENTS

ACKNOWLEDGMENTS

An appreciative thank you is tendered to the First Presbyterian Church for the use of photographs displayed in their church buildings as well as images in their church history collection. It is with gratitude I wish to thank the First Presbyterian Cemetery Restoration Committee for their support, especially Chairman Tom Beard and Jake Michel. One can never understand the complexity of restoring a historical 19th-century cemetery until one becomes involved. Each member dedicated countless hours toward restoration.

It is with deep appreciation I thank the First Presbyterian Church congregation, who extended a hearty welcome to me while visiting their beautiful cathedral. Thanks are extended to Benjamin Briggs of Preservation Greensboro Incorporated, for taking the time to personally photograph a rare painting for use in this publication. Thanks to Helen Snow of the Greensboro Public Library for her assistance in acquiring images. A grateful thank you is extended to Bill Craft for all his hard work in maintaining a garden of flowers in the cemetery. The flowers are the reason I lingered long enough to sense with my mind's eye the great blessing of an old cemetery.

A special thank you is extended to Randall Clapp of Elon for escorting me while I explored a majority of the graveyards in Guilford County and for photographs used in this book. A loving thank you is extended to the most important people in my life, my family, my friends, and my godchild, Carol, who excitely urged me forward. I wish to thank God for . . . everything!

Abbreviations used in this book are: First Presbyterian Church Archives, FPCA; Randall Clapp, RC; Greensboro Historical Museum, GHM; the Greensboro Public Library, GPL; Library of Congress, LOC; North Carolina Office of Archives and History, NCA; University of North Carolina at Chapel Hill, UNC; Greensboro Masonic Museum and Library, Inc., GMML; Documenting the American South (http://docsouth.unc.edu), the University of North Carolina at Chapel Hill Libraries, North Carolina Collection, DOC; *Greensboro Daily Record*, GDR; Greensboro Area Convention and Visitor's Bureau, GCV; Preservation Greensboro Incorporated/Blandwood Mansion, BM.

INTRODUCTION

The First Presbyterian Church Cemetery was established in 1831 when Jesse Lindsay donated land to the First Presbyterian Church as a location to erect a house of worship. The deed listing approximately three quarters of an acre of land is dated 1833. The cemetery served as a public burial ground, a churchyard, and a family cemetery in the early days of its existence. The exact date of the first burial is not known, but it is known that Fannie Sloan Logan was the last interment in 1926. The cemetery has withstood the passage of time and serves today to give one a unique glimpse into the lives of the early citizens of Greensboro, North Carolina.

The cemetery has withstood the ravages of nature. The earthquake of 1886 destroyed the Lindsay Street School located behind the cemetery. The windstorm damage through the years was surpassed by the 2002 ice storm that brought about the demise of century-old oak trees. Broken limbs came crashing down and damaged many monuments. These trees were so large that it was necessary to bring in a crane to remove many of the limbs.

The cemetery has withstood many acts of vandalism dating back to 1904. It is recorded that five monuments were completely destroyed at that time. Weather destruction and vandalism is still evident in the cemetery today in the form of fractured gravestones.

Through the years, many people have found comfort in the old cemetery. It is a place of tranquility, a place of meditation, and a sacred place. The cemetery touches persons from all walks of life. Even the homeless have frequented the cemetery and found a safe haven in which to rest a moment. Some of the senior citizens of Greensboro can recall visiting the cemetery and playing there as children. More recently, school children enjoy field trips to the cemetery.

The First Presbyterian Church proudly maintains the cemetery. It appears that in every generation members of the church unite with concerned citizens of the community to perform maintenance on the cemetery. Records dating back to 1864 give insight into some of the problems besieging the cemetery, such as the need to maintain the walkways. Another old record tells of erecting a fence consisting of seasoned white oak to protect the cemetery. Currently the walkway and fencing are a great concern, and plans are underway to build better walkways. The cemetery is protected by a beautiful brick fence and three iron gates, which are locked in the evening.

By reading the epitaphs, one will learn that many of the early citizens of Greensboro were immigrants looking for a better life in the United States. Though a Presbyterian cemetery one will find Episcopalians, Methodists, and other religious affiliations represented in the cemetery. A large number of the monuments have Bible verses carved upon them, thus lending insight into the deep religious beliefs of the citizens of 19th-century Greensboro.

First Presbyterian Church Cemetery is unique in the fact that through time it has been left as it originally existed. Modern cemeteries or those that have been restored have monuments with the inscriptions facing the same direction in perfect rows, but in this cemetery one will find inscriptions facing east, west, north, and south. The reason for this uniqueness is rather puzzling; a possible explanation for the orientation of the stones is that it distinguishes one family from another.

Popular in the cemetery is the enclosing of graves with edging or fencing. Headstones, footstones, and side rails are widely used in the graveyard. The total number of graves in the cemetery is not known to date, as several fallen stones have been covered in vegetation for years and have only recently been unearthed. There could possibly be as many as 375 graves. At the age of 175 years old, the cemetery is unique given the fact that it has not fallen victim to removal, as many inner-city cemeteries have.

The cemetery has a wide array of gravestones including plaques, tablets, obelisks, shafts, columns, pedestal monuments, bedsteads, ledgers, box tombs, and a tree monument. The artisans who created the works of art in the form of gravestones are equally varied, with signatures such as Walsh, Couper, Robertson, Lauder, Leinbach, and Brown carved upon the stones. Local artisans are represented, though they did not sign their work. Monument inscriptions dating back to the 1830s are still legible, serving as examples of the expertise of the stone carvers.

Wording on the stones is religious in nature, poetic, and prophetic. The stones range from massive works of art to simple soapstone markers with only an initial or two carved upon them. The cemetery is laid out in family plots mostly rectangular in shape. Several of the family plots are protected by ornate iron fencing decorated with finials. The monuments and fences are adorned with symbolic motifs.

The cemetery offers a refuge not only to people but to wildlife. North Carolina's state bird, the cardinal, is a regular visitor, as well as assorted butterflies and lizards. There is at least one resident rabbit and a multitude of squirrels.

Plant life in the cemetery ranges from those naturally planted by nature to exotic tropical plants. The American holly tree in the cemetery is possibly the largest in North Carolina. The pine tree, North Carolina's state tree, is represented in the cemetery as well as the state flower, the dogwood. The old graveyard is a Victorian paradise with camellias, azaleas, rhododendrons, lilies, and daffodils planted in profusion. Flowers bloom year round in the cemetery. The decorating of graves with flowers is documented as far back in time to 1834 when a young mother felt it was a mother's tears that made the flowers bloom so profusely. In the late 1860s, women took an active interest in planting flowers in memory of the deceased. In the 21st century, many of the beautiful flowers of today are the result of the labors of Bill Craft.

After the death of a loved one in 19th century, Greensboro burial was usually the next day. For several of the Civil War soldiers buried in the First Presbyterian Church Cemetery, it was their second burial. Their bodies were retrieved from the battlefield and as far away as Washington, D.C., at the end of hostilities in the United States. There is record of as many as three burials in one day. The erection of tombstones came much later, when the family could afford them or when a stone carver became available. Thus one will notice many identical grave markers amongst family members.

The early settlers and builders of the city of Greensboro are interred in this garden cemetery conveniently located behind the Greensboro Historical Museum at 130 Summit Avenue in Greensboro, North Carolina.

Each monument is a work of art with a story told by the weathered inscriptions and symbols hand carved upon the stones. Due to loving hands, hearts, and generosity throughout the centuries, the blessed cemetery will exist into the future to tell unborn generations the stories of the early days and citizens in Greensboro, North Carolina.

One

BUILDERS OF
CITY AND STATE

Greensboro came into existence when a need arose for a more central location to handle the legal affairs of the citizens. Folks complained about the great distance to travel to attend court. It was decided that a more central location was needed, and surveyors sought the center of Guilford County. This proved to be a problem, as it was located in a swamp; the nearest dry elevation was decided upon. The builders of Greensboro's First Presbyterian Church are the families that built Greensboro. Shown are members of the Sloan family, from left to right: (first row) Mrs. Ida Louise Sloan Ellington, Fanny Logan, Robert Moderwell Sloan, and Mrs. Julia Sloan Mebane; (second row) Roberta Porter, Mrs. Mattie Barringer, and Mrs. Virginia Sloan Scales. (GHM.)

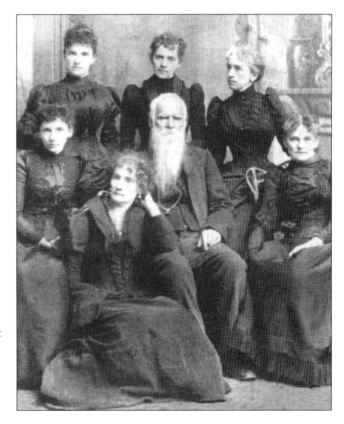

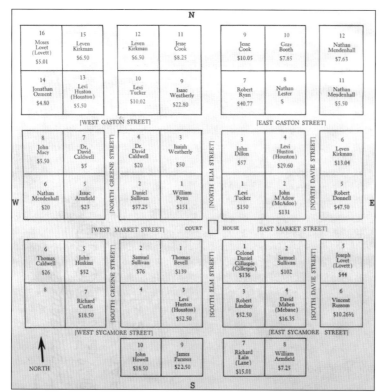

The first plat of Greensboro, which was founded in 1808, names the original purchasers of town lots. The surnames Weatherly, Houston, Caldwell, Donnell, McAdoo, Armfield, Mebane, and Lindsay will also be found carved upon the gravestones in First Presbyterian Church Cemetery. Levi Houston paid $5.50 for one lot, $52.50 for another, and $29.60 for the third lot. The main streets were named North, South, East, and West Streets. The first courthouse was located in the center of these streets. (GHM.)

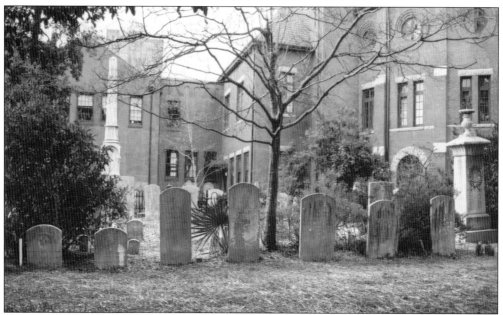

The Houston family plot is depicted below. Levi Houston, one of the original purchasers, was born on January 17, 1771, and died on August 19, 1862. Levi's wife, Anne Boyd Houston; children Dr. Nathaniel B., Margaret McAdoo, Mary B., David Brainard, Dr. C. William M., and John B.; and John B.'s wife, Harriet N., and their son, Seymour P., have existing tombstones in the cemetery. (RC.)

Ralph Gorrell (1803–1875), son of David and Euphemia Gorrell, was an attorney and church elder who served in the house of commons, as a state senator, and as a Guilford County clerk. At the age of 16, Gorrell wrote a poem titled *The Courtyard.* "In the streets of Greensboro is to be seen/ Plenty of women fat and lean/ some selling, some buying,/ and everyone for her own advantage trying./ Some in taverns getting drunk/ And lighting their pipes with smoking punk./ Some selling apples, chestnuts and cake,/ Each one trying how much she can make./ Plenty of men are also to be seen/ Some very dirty and some tolerably clean." Gorrell defended the abolitionist Daniel Worth. Shown below is the Gorrell monument. (Top: FPCA.)

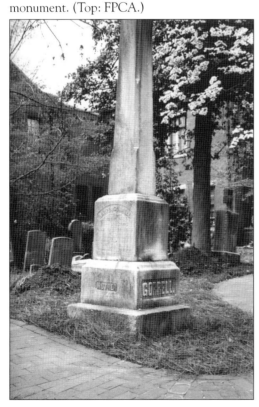

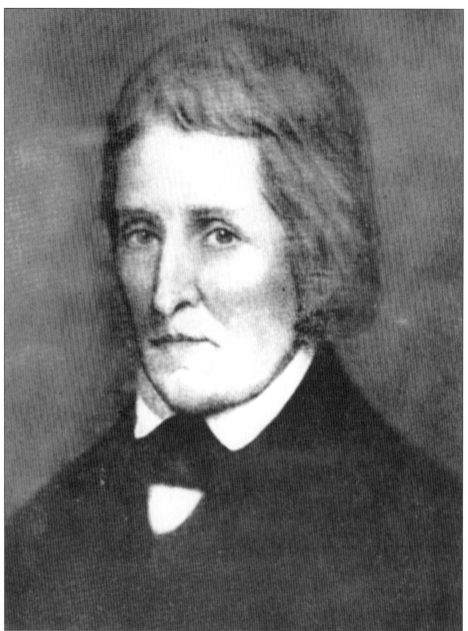

The Reverend William Denny Paisley (1770–1857), lovingly referred to as Father Paisley, was the son of John and Mary Ann Denny Paisley. Paisley participated in the revivals in the late 1790s and early 19th century that swept throughout the South. Behavior described in a few of these revivals was considered bizarre by many. People talked in tongues and exhibited wild gyrations with fainting spells. This behavior was deemed suspicious because up to this point in time, religious services were very strict. Paisley moved to Greensboro in 1820 and was active in promoting education, establishing the Paisley Male Academy and the Female Academy, run by his daughter. In 1824, he established the First Presbyterian Church in Greensboro. His goal in life was to save souls. The entire town shut down upon hearing of Paisley's death. Mourning drapery adorned every building in town. (FPCA.)

Frances Mebane Paisley (1779–1859) was the daughter of Gen. Alexander Mebane and the wife of Rev. William Denny Paisley. Shown below are the box tombs of the Paisleys, located in the family plot. Paisley's slab reads in part, "He came to his grave beloved and revered in a full age as a sheaf of corn in its season and in the mature and blessed hope and assurance of the resurrection of the body and life everlasting." In addition, on his tomb are the words "the founder of the Greensboro Church and its first preacher for twenty years." Frances's marker reads, "More than half a century she was the wife of the Rev. William D. Paisley and his cheerful and hearty helper in the labor and joys of their common Christian service and toil." (Top: FPCA.)

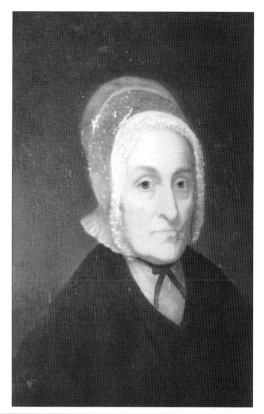

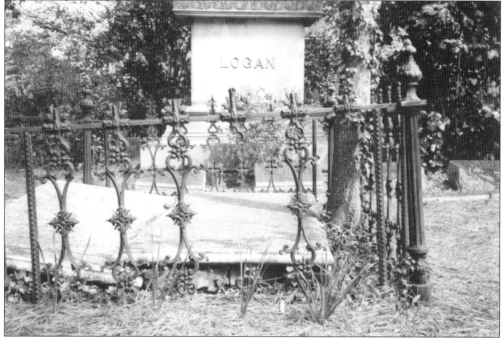

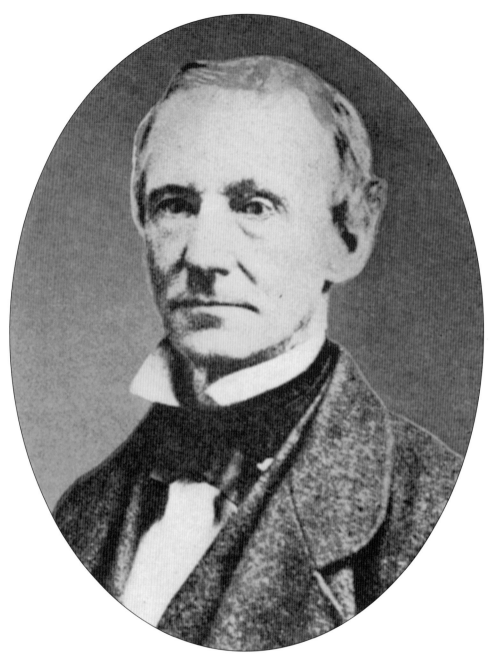

Jesse Lindsay (1808–1886) donated land to the First Presbyterian Church to erect a place of worship in 1831. He is the son of Robert and Letitia Harper Lindsay born in Martinsville, the former county seat of Guilford. He was a University of North Carolina graduate, an early commissioner in Greensboro, a store owner, he served in the house of commons for four years starting in 1834, and he served in the North Carolina Senate in 1844. In 1849, he served the First Presbyterian Church as an elder. He was a cashier of the Bank of Cape Fear and president of the Greensboro National Bank. Lindsay was trusted for his honesty and intelligence. He was called upon for advice by leaders of city and state. On his monument is inscribed "With Christ which is far better." Lindsay's initials are carved in the top center of the monument. (FPCA.)

Amelia Ellison Lindsay (1816–1881), the wife of Jesse, was the first president of the Ladies Sewing Society, established in 1855. The society raised funds to help the church with its needs and was a later name of the Female Benevolent Society, which was established to raise funds for the building of the First Presbyterian Church. This women's society has existed since 1830, though through the years the name has changed. Founding members Frances Paisley, Celia Mebane, Julia Gilmer, Eliza Overman, Annie Cummins, Ann Mebane, Anne Eliza Morehead, Parthenia Dick, Christia Hogg, Lydia Hogg Lindsay, Catherine Gilmer, Ann Houston, and Mary Morehead are interred in the cemetery. Shown below are the Lindsays' gravestones. On Amelia's stone are carved the words "Forever with the Lord." (FPCA.)

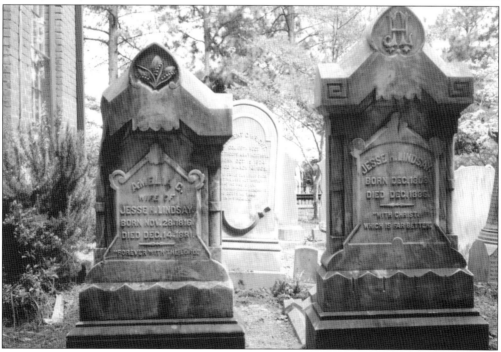

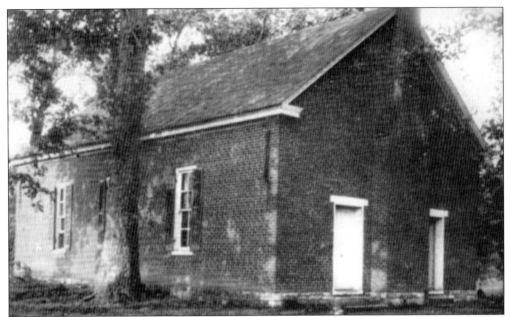

Above is an artist's rendition of the first church building. First Presbyterian Church was established in 1824 by 12 charter members: Molly Paisley, Mary Paisley, Frances Mebane Paisley, Ann Mebane, Elizabeth Caldwell, Mrs. Robert Carson, William Lindsay, and Justin Field; and four African Americans in bondage, Tony, Milly, Molly (Paisley), and Kezia (Carson). The first service in the building was in 1832. (FPCA.)

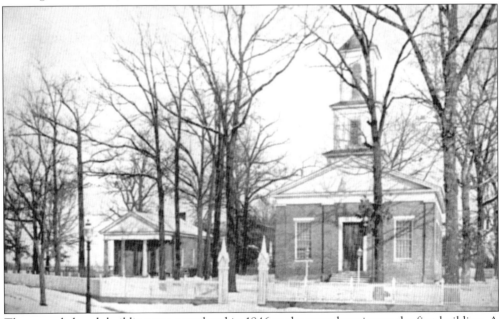

The second church building was completed in 1846 at the same location as the first building. A Bible, coins, newspapers, and a tablet listing church members and local leaders were placed in the cornerstone of this building. On the building committee were John Logan, Jeduthun Lindsay, James Sloan, Jesse Lindsay, and David Weir, all of whom are interred in the First Presbyterian Church Cemetery. (FPCA.)

16

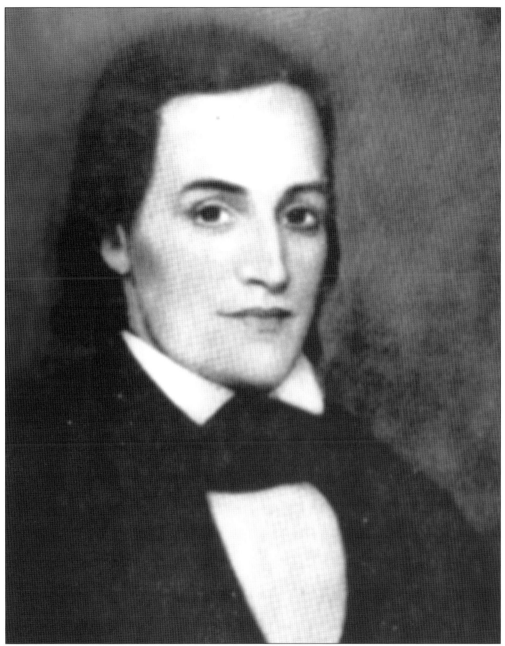

Rev. John Augustus Gretter (1810–1853), son of Michael and Joanna Hewlett Gretter, was born in Virginia of German descent. Gretter taught school in Greensboro at Caldwell Institute. He became the first pastor of First Presbyterian Church, answering the call to the pastorate in 1844. Gretter's life would be cut short by consumption, which he suffered from greatly for 10 months. He is buried in the Gretter family plot amongst family members. He was survived by his wife, Mary Winn, and eight children. Thomas Chalmers and George King Gretter predeceased their father and are interred in the family plot. Six-year-old George, a student at Caldwell School, died from the fever epidemic besieging Greensboro. His little body was carried to the cemetery by schoolmates. (FPCA.)

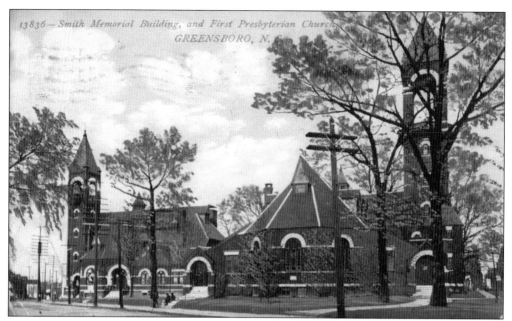

The third church building, erected on the same site as the previous church buildings, now houses the Greensboro Historical Museum. The cornerstone was laid with full Masonic rites in 1890. The building is on the National Register of Historic Places and is located on Summit Avenue. This building was used for church services until the completion of the fourth building.

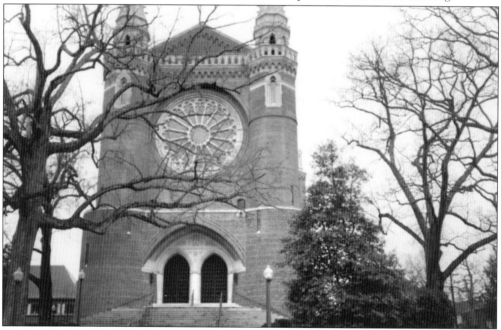

The fourth church building's cornerstone was laid with Masonic rites in 1928. The first service was held in the building in 1929. The building is a Gothic cathedral design located on North Elm Street. The Richardson family purchased the third building from the church in part to preserve it and donated the property to the city of Greensboro to use as a library, civic center, and later as a museum.

18

Christopher Moring (1789–1836) was a son of John and Anne Moring of Virginia. Moring was one of the firsts in much of early Greensboro's history. When the town government was first established and recorded Moring along with William Adams, John M. Dick, John Hubbard, and Robert Moderwell became the first town commissioners. In 1824, Moring served as trustee of First Presbyterian Church during its organization, and in 1832, he served as church elder. In 1821, the Greensboro Masonic Lodge, known as the Old 76, was established. Moring was the first Master Mason of the Old 76. Moring owned a hotel located on the southeast corner of East Market and Davie Streets. Below is Moring's gravestone. Inscribed are the words "Blessed are the dead who die in the Lord." (Top: GMML.)

John McClintock Dick (1791–1861), a son of James and Isabella McClintock Dick, was born in the Rock Creek section of Guilford County. Dick graduated from the University of North Carolina and supported that institution throughout his life. Dick was the second master mason of Masonic Lodge 76. In 1829, he was one of the first town commissioners. He served in the state senate in 1819 and again from 1830 to 1832. In 1835, Dick was elected superior court judge and served in that position until his death. For 26, years he rode the circuit on horseback. (GMML.)

Parthenia Paine Williamson (1800–1881), a daughter of James and Susanna Paine Williamson, became the wife of John McClintock Dick in 1821. She was a charter member of the Female Benevolent Society of First Presbyterian Church. Parthenia and the other members of the society busied themselves with selling their hand-sewn items and often held bazaars and bake sales to help support the needs of First Presbyterian Church. The couple's home was located on North Elm Street. The Dick monument has a motif of a hand with the index finger pointing downward, symbolizing the calling of those on Earth to bear witness of the victory over death. The words "At Rest in Heaven" are carved upon the marker. (Top: GDR.)

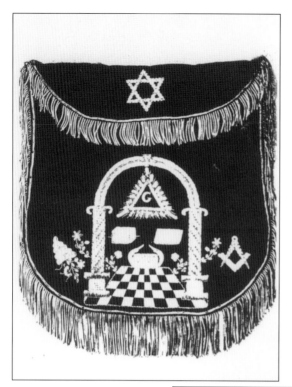

The apron of John McClintock Logan has many Masonic symbols displayed upon it. Many of these symbols can be found carved upon the gravestones in the First Presbyterian Church Cemetery. Amongst the early members of the Old 76 are the pioneers and builders of Greensboro, and many of them are sleeping the long sleep of death in the First Presbyterian Church Cemetery. (GMML.)

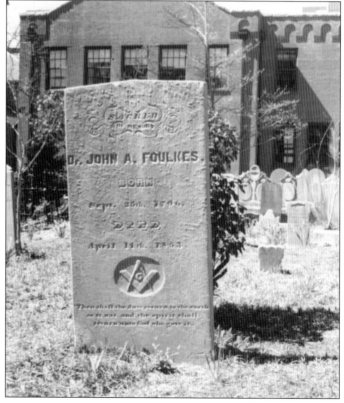

The monument of John A. Foulkes (1796–1853) depicts the Masonic symbol of the straight edge and compass carved upon it. Foulkes was practicing medicine in Greensboro by 1826. It was customary for the Masons to wear crape armbands for 30 days as a symbol of mourning as well as to assist the family of the deceased with burial arrangements.

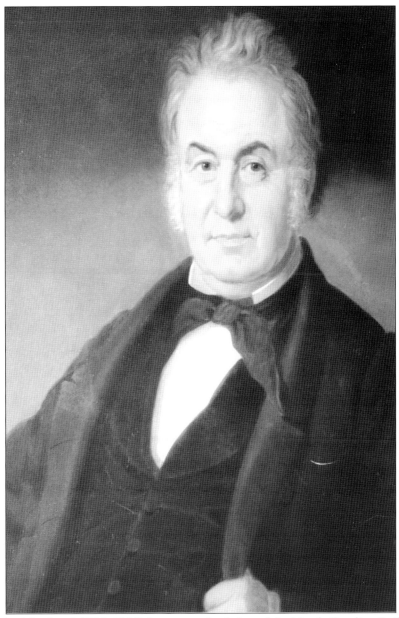

John Motley Morehead (1796–1866), known as the father of the North Carolina Railroad, was governor of North Carolina in 1841 and served for two terms. His life was dedicated to improving his beloved state of North Carolina in the areas of transportation, mental institutions, educational opportunities, and special schools for the blind and the deaf. He envisioned roads and railroads from Morehead City on the coast of North Carolina extending all the way across the state to the mountainous western section. Morehead promoted the education of women by establishing Edgeworth Female Seminary, which his five daughters attended. John was a slave owner who taught his slaves skills and was on more than one occasion called an Abolitionist and a Black Republican for his progressive views in regard to those in bondage. Morehead, an attorney, was in the North Carolina Senate in 1860. He served in the Congress of the Confederate States of America in 1861. (GPL.)

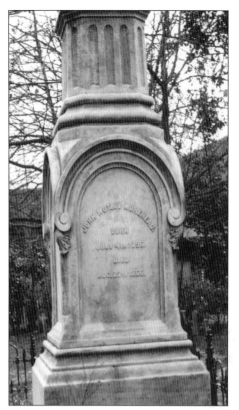

John Motley Morehead's towering monument doesn't give a clue to his contributions to city and state. In 1855, he stated, "Living, I have spent five years of the best portion of my life in the service of the North Carolina Railroad—dying, my sincerest prayers will be offered up for its prosperity and its success—dead, I wish to be buried along side of it in the bosom of my own beloved Carolina!" To this day, the train passes near his grave. In the wrought iron–fenced family plot rests the bodies of his wife, Ann Eliza, his son-in-law, William R. Walker, and his nephew, James Turner Morehead. Carved on Morehead's monument are the words "Severed on Earth, we shall meet again. Mark the perfect man and behold the upright."

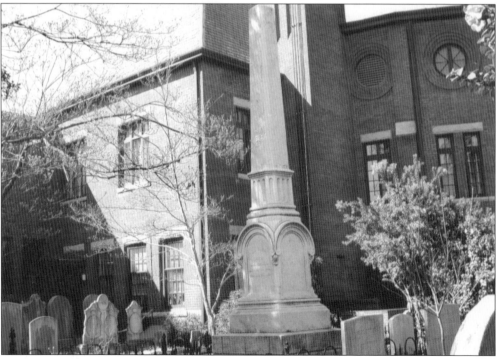

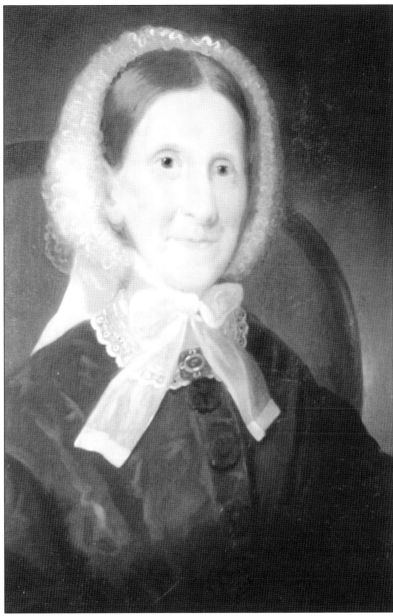

Ann Eliza (1804–1868), a daughter of Col. Robert and Letitia Harper Lindsay, married John Motley Morehead in 1821. A letter written on her behalf by her husband to Gen. Braxton Bragg in 1864 requesting that her son, Eugene, be allowed to attend a wedding describes some of the hardships she and her family endured during the Civil War: "My wounded son, Turner, is to be married on 6th December. He is only a few years older than my youngest child, Eugene L. Morehead, now a private in Captain Barron's Heavy Artillery. He has been absent since March. His mother is very feeble, but insists she must see him—and will go to Wilmington for that purpose if it becomes necessary. The loss of two sons-in-law in this war, one son shot through the head and an invalid for life, three nephews at home on crutches, besides some half-dozen, which have fallen in the service, are stubborn facts well calculated to impress her mind with the fear, that she may never see her youngest again." (GHM.)

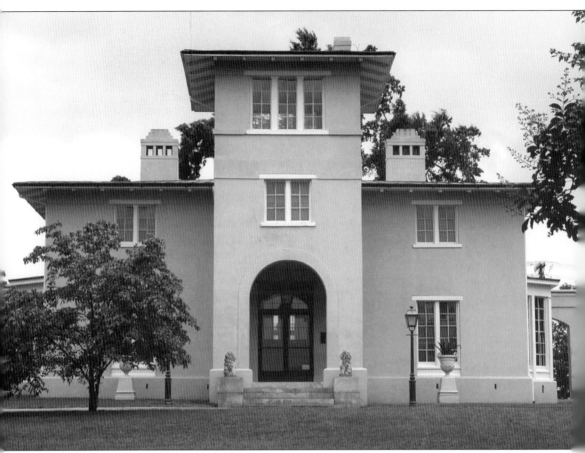

Beautiful Blandwood, home of the Morehead family, first existed as a farmhouse. It was enlarged in the 1820s and again in 1844. Morehead hired Alexander Jackson Davis, a noted architect, to enlarge the house in an Italian villa style. This style would become very popular in the South. As was the custom of the day, the kitchen was located outside of the house. There was also a law office located on the property for Morehead's use. Ann Eliza was rather a quiet person and had her own little private room she could retreat to in the house when her husband was entertaining or had business associates. Letitia, Morehead's daughter, served as hostess of Blandwood. The couple had eight children to reach adulthood. Other than their child, Letitia, the remaining seven were born at Blandwood. Blandwood is on the National Register of Historic Places. (GVC.)

Jeduthun Harper Lindsay (1806–1881) was a son of Robert and Letitia Harper Lindsay. Jed was on the building committee of the First Presbyterian Church building in 1832. He was a farmer, business owner, sawmill owner, and was elected town commissioner in 1837. In 1854, he gave the First Presbyterian Church land to serve as a hitching lot for the church members' horses. (LOC.)

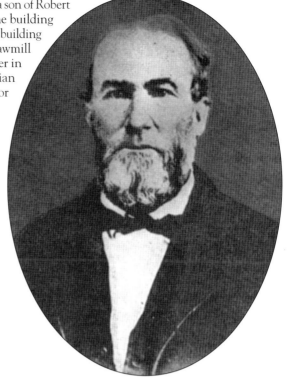

Jed obviously enjoyed reading and keeping up with the news, as the *Greensboro Patriot* newspaper gives notice that Jed had renewed his subscription to the *Patriot* in 1878 for the 50th time since 1828. Pictured are the gravestones of Jed and his wife, Martha. Recently unearthed, these stones are awaiting restoration. Jed's white marble stone bears a Masonic symbol, and Martha's is adorned with a flower motif.

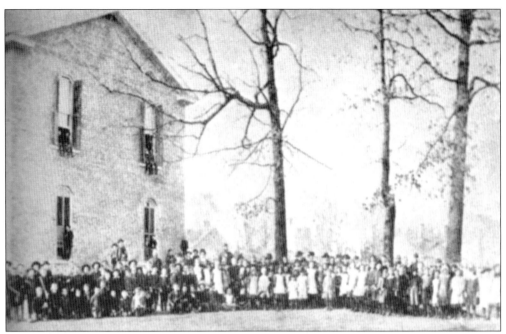

Jed owned the land in which Greensboro's first white graded school was built. The school was located on the corner of Lindsay and Forbis Streets and was known as the Lindsay Street School. Notice the children in the windows. The building pictured above was erected in 1875. Due to damage received during the Charleston earthquake in 1886, a new building was needed to replace the first. The second building, pictured below, served as a school until 1925. Interestingly the school was located near the First Presbyterian Church Cemetery, and the school asked the church if they could move the cemetery fence back a distance so the children could use the extra space as a playground. The school building does not exist today. (GHM.)

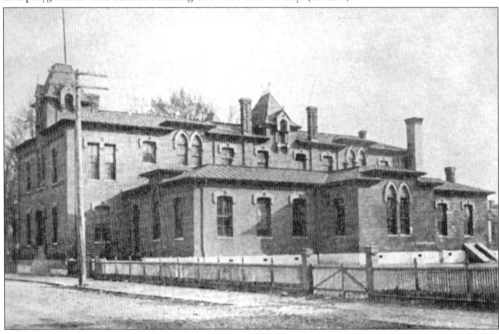

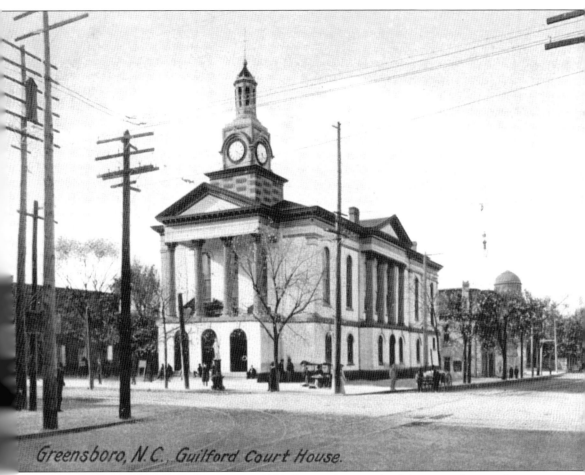

Greensboro, N.C., Guilford Court House.

The first court held in Greensboro was in 1809. Due to the growth of the town, the courthouse was removed from the center of the street to a corner. Court days in early Greensboro were cause for celebration. People came from miles around to settle their legal affairs. The merchants ordered supplies well in advance in anticipation of the extra goods the swelling population would purchase. Many of the folks living in the country did not come into town except on court days. The country folk looked forward to catching up on news with their city friends. Livestock was actively traded in the center of the street. Due to a small pox epidemic in 1849, court day in Greensboro was avoided by the citizens in fear of the disease. Business leaders feared financial ruin over the event. Fire completely destroyed the courthouse in 1872. Jed Lindsay was given the job of overseeing the rebuilding of the courthouse.

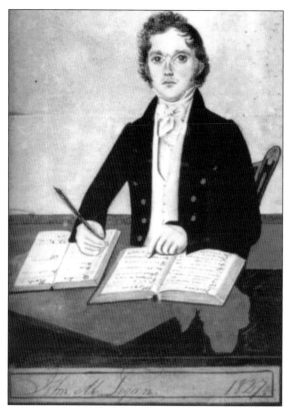

John McClintock Logan (1797–1853) was born in Ireland to Alexander and Isabella McClintock Logan. When the town of Greensboro was first organized, Logan was public officer and tax collector. Logan was given the job of making sure that all two-story homes in Greensboro had a ladder in case of fire. Logan served as commissioner and county clerk. He was Greensboro's first policeman. In 1841, four people escaped from his jail. He ran an ad in the newspaper stating "The man charged with larceny of money not bacon was lashed at the last county court and probably still had the marks upon the back." The act of public lashings for crimes committed was quite common in early Greensboro. Logan was active in the Greensboro Guards, the local militia. Shown below is Logan's monument. (Top: GHM.)

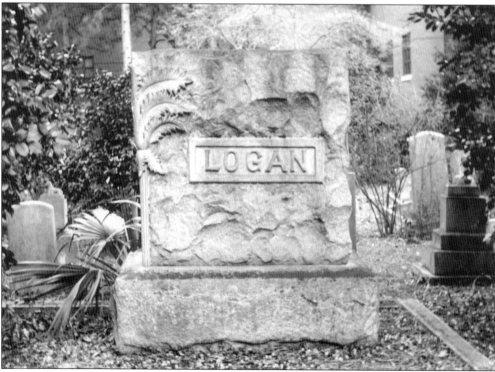

James Turner Morehead (1799–1875) was a son of John and Obedience Motley Morehead. He was in the state legislature from 1835 to 1844 and in the U.S. Congress. He was an attorney. James fought and lost the case of a man accused of murder. The man was found guilty of manslaughter and sentenced to a year in jail, ordered to pay a bond of $1,000, and was to be branded in the hand. James fought hard to prove the guilty man had a good family, that he fell upon hard times, and that he drank too much, and to brand him in the hand would forever be a disgrace and hinder his chances of redeeming himself. James, lovingly called Uncle Jimmy, lost the case, and the man was branded. Shown below is James's tombstone.

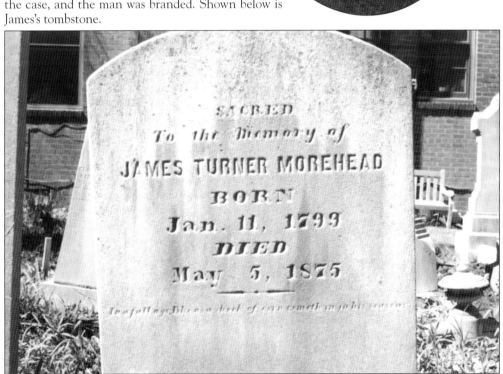

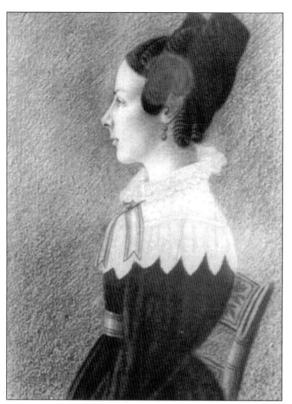

Mary Teas, the daughter of Robert and Letitia Harper Lindsay, married James Morehead in 1830. She was a charter member of the Female Benevolent Society. Mary is described as a woman "of many virtues and of fine character and intellect." James traveled by horseback to court young Mary. Mary was the sister of Ann Eliza, who married James's brother John. She succumbed to consumption in 1847, leaving her husband with six young children. A son, J. Henry, died during the Civil War. Another son, Robert, received a vaccination during the war from which he never fully recovered. A daughter, Mary, died from typhoid fever. Below is Mary's gravestone with the Bible verse, "Jesus saith unto her, said I not unto thee, that if thou wouldest believe, thou shouldest see the glory of God." (Top: GHM.)

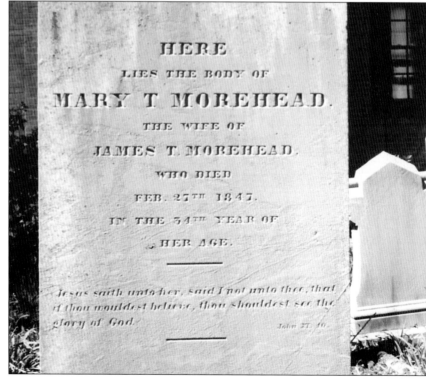

Two

WAR!

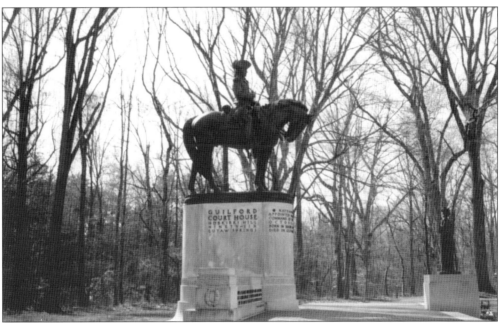

The statue of Maj. Gen. Nathanael Greene is located at Guilford Courthouse National Military Park in Greensboro. Greene, a hero of the American Revolution, was so beloved that when the courthouse was removed from Martinsville to a central location in Guilford County, the hamlet was named Greensborough, now Greensboro, in honor of him. Though Greene lost the battle of Guilford Courthouse, he successfully weakened the British troops led by Charles Cornwallis. The battle has been a source of pride throughout time to the citizens of Greensboro. Annual celebrations are held at the park each year; the first one of record was held in 1788, with Andrew Jackson in charge. During the first celebration, speeches were made, picnics were shared, horses raced, and cockfighting was the rage, as well as gander pulling. Gander pulling was rather barbaric, as it involved greasing a gander and hanging it upside down from a tree limb. A horseback rider tried to separate the gander's head from its body by pulling on the head as he rode past.

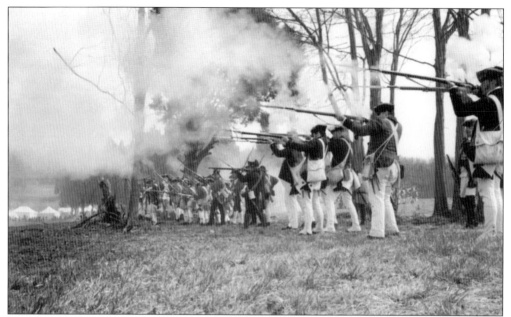

The above scene is from the 225th anniversary of the Battle of Guilford Courthouse. People travel from across the United States to take part in the reenactment. Folks today watch the reenactment, enjoy music from the era, feast on cotton candy and hot dogs, and shop for 18th-century reproductions as well as tour the British and American camps.

An ancestor of the Morehead family, Kerenhappuch Turner, rode on horseback to aid a son injured in the Battle of Guilford Courthouse. In 1857, the Greene Monument Association was created to erect a monument in honor of the battle. Charter members John M. Morehead, John A. Gilmer, Jesse H. Lindsay, Ralph Gorrell, William L. Scott, David Weir, Jed Lindsay, and James Sloan are buried in the First Presbyterian Church Cemetery.

WILLIAM CUMMING
CAPT NC MILITIA
REVOLUTIONARY WAR
JAN 18 1759 APR 18 1849
SOLDIER OF THE REVOLUTION

Revolutionary War veteran William Cumming (1759–1849) was at Valley Forge, at Camden in 1780, and was held prisoner during the Battle of Guilford Courthouse in 1781. As the British Army marched to Guilford County, William and his brother, Henry, were forced with them. William related that during the battle, when the North Carolina Militia fired into the British troops, the British were hit with such force that Cornwallis ordered the guard at New Garden to retreat and take the baggage and prisoners to another location. William escaped. His obituary reads "Peace to the remains of the old Soldier, and shame be upon posterity should they forget the debt of gratitude they owe him, or neglect the spot where his sacred dust is laid!" Pictured above is William's military grave marker. The picture at right is the Cumming family plot.

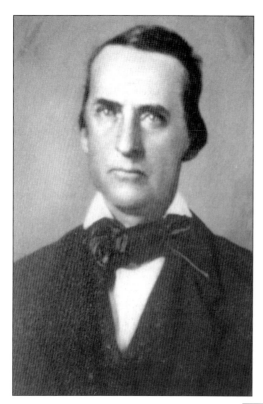

In his old age, Cumming moved to Greensboro to the live with his son, William H. (1800–1863), shown. William was a leader in the community and a Presbyterian Church elder. William's wife, Lavinia (1805–1889), is buried beside him. On her gravestone are the words "Underneath are the Everlasting Arms. Deut. 33:27." Shown below is William's gravestone in the Cumming family plot. (Top: FPCA.)

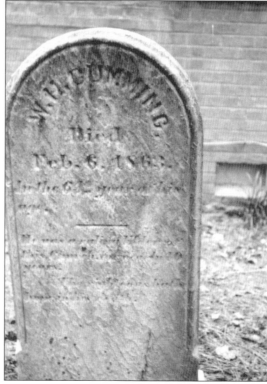

The Francis McNairy house, shown at right, was used as a hospital by Dr. David Caldwell during the Guilford Courthouse battle. The Christian Isley house (below), originally located in eastern Guilford County, was built c. 1788. Both houses were moved from their original locations and are now part of the Greensboro Historical Museum. The houses, kitchen, a blacksmith, and carpentry shops are located directly behind First Presbyterian Church Cemetery in the Mary Richardson Park. Each house offers visitors a glimpse into the daily lives of the early citizens of Guilford County and how those interred in First Presbyterian Church Cemetery may have lived.

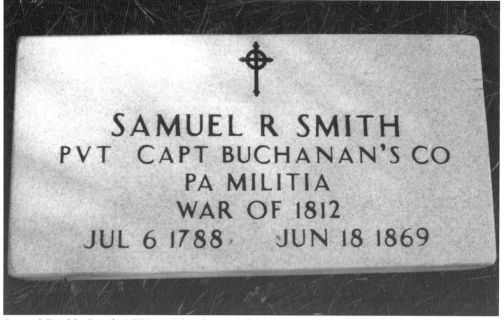

SAMUEL R SMITH
PVT CAPT BUCHANAN'S CO
PA MILITIA
WAR OF 1812
JUL 6 1788 · JUN 18 1869

Samuel Runkle Smith (1788–1869) volunteered for service as a private during the War of 1812 and served during the summer of 1814. Smith was in Capt. Thomas Buchanan's Company of Pennsylvania Militia. He enjoyed telling of his war experiences, particularly the British attack on Baltimore, Maryland, and on Fort McHenry. He married Margaret K. Fuller on October 22, 1818. Inscribed on Smith's gravestone, shown below, are the words "Died in Greensboro at the residence of his son, Reverend J. Henry Smith D.D. Absent from body and present in the Lord. By grace are ye saved through faith and that not of yourselves, it is the gift of God." Another War of 1812 veteran, Jesse McCuiston, is interred in an unknown location.

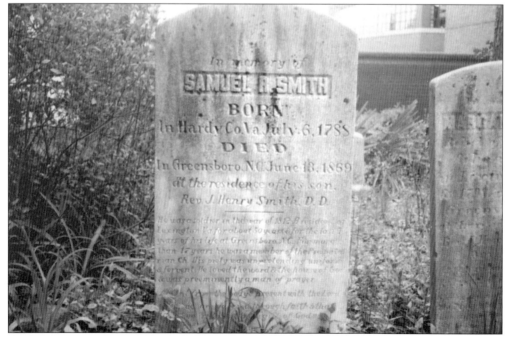

John Adams Gilmer (1805–1868) was politically and privately active in promoting the causes of city, state, and nation. Gilmer Township in Greensboro is named in honor of him. He served as senator representing North Carolina before the Civil War. He was a Whig and a Unionist who pleaded to keep the country together on the eve of the American Civil War. Gilmer turned down a cabinet post tendered by Pres. Abraham Lincoln to stand with his beloved North Carolina when the state seceded from the Union. He openly admitted shedding tears over the events leading to the Civil War and brought many people to tears with his eloquent speeches pleading to the nation to find a peaceful resolution. He would later become a member of the Congress of the Confederate States of America. With the ending of the Civil War, his political career also came to an end. (NCA.)

The heavily shaded Gilmer family plot, with its damaged ornamental fencing, does not lend a clue to the merits of the man nor his family there sleeping the sleep of death. Gilmer lost his first-born son, William Paisley Gilmer, when the child was six years old. A portion of the child's obituary from the *Patriot* newspaper of February 1842 reads "Life is a span, a fleeting hour, how soon the vapor dies; Man is a tender, transient flower, that e'en in blooming dies." Gilmer's wife, Julia, their daughter, Mary Shober (who died from complications of childbirth), and an unnamed son and a grandchild are buried in the family plot, as well as Rev. William D. Paisley and his wife, Francis. Below is Gilmer's obelisk marker with simply his name, birth, and death dates inscribed.

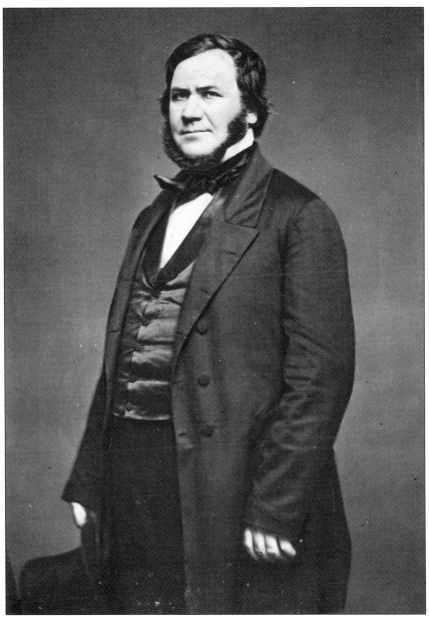

This image of Gilmer standing depicts the style of clothing worn by a 19th-century gentleman. One of Gilmer's speeches preceding the Civil War includes the following: "I want gentlemen North and South to mark my words: when this country shall be laid waste; when all our channels and communications of trade shall be broken up; when the shipping in our ports shall be destroyed; when our institutions of learning and religion shall wither away or be torn down; when your cities shall be given up for plunder and for slaughter; when your sons and my sons, your neighbors and my neighbors, shall be carried from this bloody field of strife; and our mothers, our sisters, our wives and our daughters, shall assemble around us, and, with weeping eyes and aching hearts, say; 'Could not thou have done something, could not you have said something, that would have averted this dreadful calamity?' I want to feel in my conscience and in my soul that I have done my duty." (LOC.)

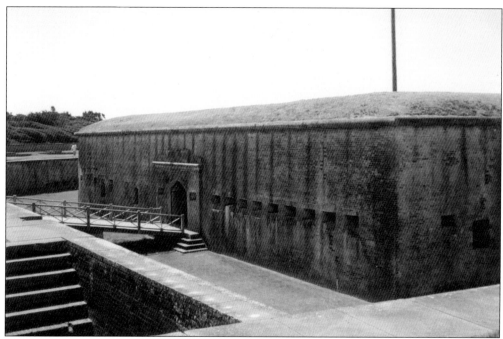

The Guilford Grays, the first regiment to leave Greensboro to serve in the Confederate army, left by train for Fort Macon in April 1861. The townspeople turned out in droves to watch the young men march proudly through town to the train station. The Grays were told by Gilmer to defend North Carolina whether the enemy came from the North or from the South. North Carolina would secede from the Union the following month, and the Guilford Grays would become the 27th North Carolina, Company B. Fort Macon, pictured above, is located on the coast of North Carolina and is now a state park open to visitors. Below is the gravestone of Robert Henry Lindsay, one of the first from Greensboro to die in the war. The Southern Cross of Honor is carved in the top center.

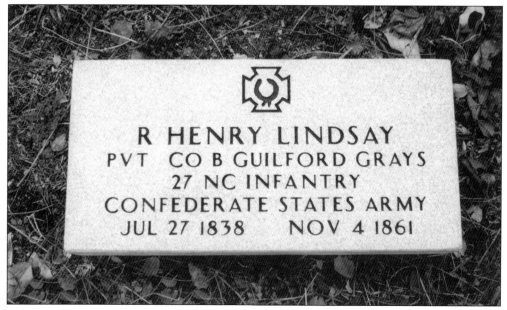

R HENRY LINDSAY
PVT CO B GUILFORD GRAYS
27 NC INFANTRY
CONFEDERATE STATES ARMY
JUL 27 1838 NOV 4 1861

Col. John Alexander Gilmer of the 27th North Carolina, a son of John Adams Gilmer, was a childhood friend of Samuel P. Weir. On the evening of December 13, 1862, as the battle of Fredericksburg was waning, Samuel frantically urged John, who was severely wounded in the leg, to leave the scene of battle. Samuel was shot through the left temple and killed instantly. These childhood friends, both graduates of the University of North Carolina and members of the First Presbyterian Church, parted forever that evening on the battlefield. John was maimed from battle wounds and walked with a limp the rest of his life. He married Sallie Lindsay, a daughter of Jesse Lindsay. In antebellum Greensboro, Sallie was professed to be the most beautiful girl in town. The couple is interred in Greenhill Cemetery in Greensboro. (NCA.)

The graves of Samuel Weir and his father, David Park Weir, in the Weir family plot are covered in periwinkle. Before the war, Samuel studied to be a Presbyterian minister. He spent the early days of the war handing out religious tracts and serving as chaplain at Fort Macon. In 1862, he left the Guilford Grays to serve as a lieutenant in the 46th North Carolina, Company F. Samuel's memorial reads in part "He sleeps the sleep of the blessed, and no spot on earth contains a more gallant soldier, a truer patriot, or a more faithful and sincere friend." The Weir family home is pictured below. The house, listed on the National Register of Historic Places, is in its original location on Edgeworth Street. It is now home to the Greensboro Woman's Club.

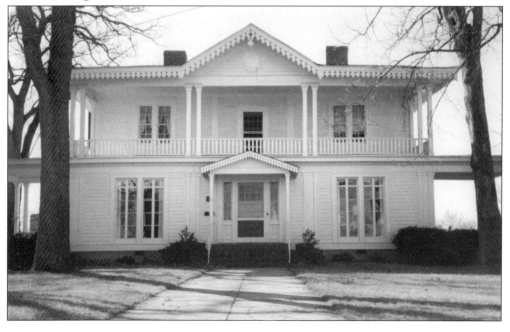

Shown above is battle-torn Fredericksburg, Virginia. John, a former slave of the Gilmer family who was with the younger John Gilmer, at this battle earned a pension for his service in the Confederate army. After emancipation, John took the surname of Gilmer and moved to Winston-Salem, North Carolina. (LOC.)

This *Patriot* newspaper advertisement for Greensboro Mutual Life Insurance and Trust Company in 1858 advertises that, in addition to insuring the lives of the persons purchasing insurance, the company would also insure the lives of their slaves. Supposedly insurance companies insuring the lives of slaves never paid off, as the contracts were worded with many loopholes.

45

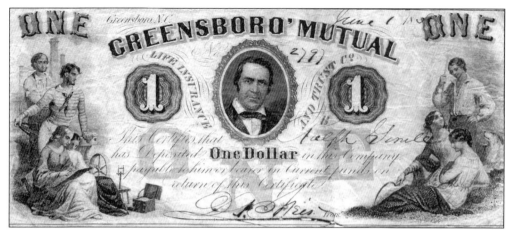

Greensboro Mutual Life Insurance and Trust Company, established in 1851, issued script in $1 and $2 bills. Interestingly this note depicts the image of John Gilmer, is payable to Ralph Gorrell, and is signed by David P. Weir, all three of whom are interred in this sacred cemetery. Pictured below is the $2 bill dated 1857 and payable to James Sloan. Sloan is buried in First Presbyterian Church Cemetery. The picture on the bill is possibly that of David P. Weir. The citizens of Greensboro placed great value in saving for the future. The company paid interest, thus enabling a person's assets to grow. This company went bankrupt during the Civil War.

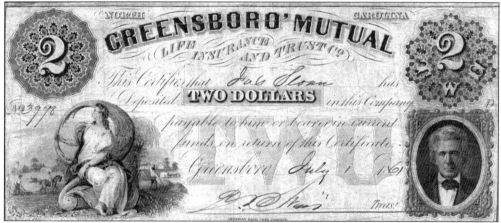

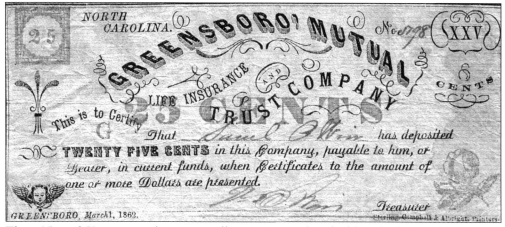

These 25¢ and 50¢ notes are known as wallpaper notes and are highly valued among collectors of today. The 25¢ note dated March 1, 1862, is payable to Samuel P. Weir, the son of the treasurer of the company. The 50¢ dated March 1, 1863, is payable to J. Sloan. Notice that the dates on these notes are from the Civil War era thus indicating attempts to save for the future even during times of war. The notes were printed in Greensboro by Sterling, Campbell, and Albright.

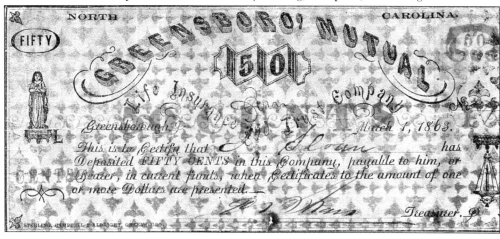

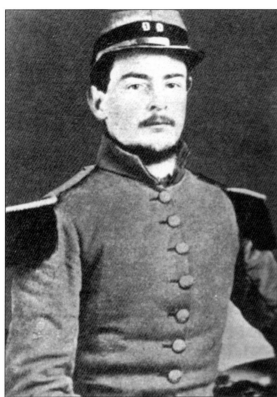

Maj. Robert Dudley Weatherly, pictured in his Guilford Gray uniform, was mortally wounded at Bristow Station in Bristow, Virginia, on October 14, 1863. Col. John Gilmer of the 27th North Carolina was leading his men from the woods in a downward assault on the enemy forces behind the railroad embankment when he was seriously wounded. (GHM.)

The bullet that hit Gilmer had already passed through the body of Weatherly. Weatherly was wounded in the groin and left hip. He was taken by ambulance wagon to Richmond. The trip took five days, and he lingered another five days, developing erysipelas, a bacterial infection. Weatherly died on October 24, 1863. Shown above on the left is his monument in the Weatherly family plot.

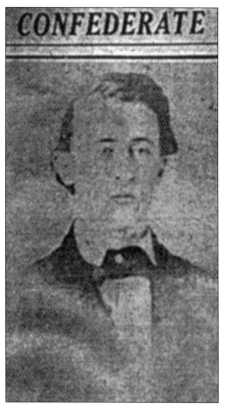

In 1860, Henry Clay Gorrell accepted a banner tendered by the students of Edgeworth Female Seminary on behalf of the Guilford Grays. The presenting of banners was duplicated throughout the South in the early days of the Civil War. In 1861, Gorrell left the Grays and raised men for service in the 2nd North Carolina, Company E. In 1862, Gorrell was mortally shot through the forehead leading his men at Chickahominy, Virginia. Before Gorrell's burial on the battlefield, his pockets were pillaged. At about the same time, Gorrell's brother, Julius, was extremely sick in Richmond. Gorrell's father, Ralph, retrieved Henry's body. Julius later died from disease. Ralph, with a broken heart, buried both of his sons on the same day in First Presbyterian Church Cemetery. Below is Henry's gravestone. (Top: GDR.)

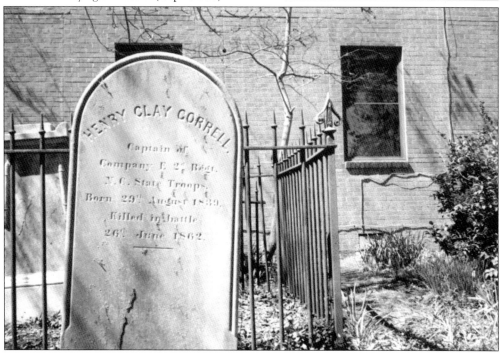

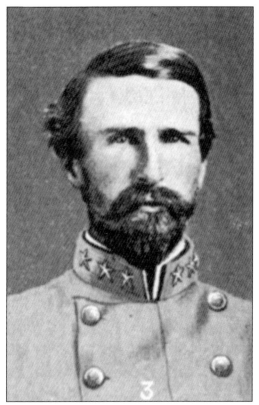

J. Henry Morehead, son of James T. and Mary Morehead, was described in *Histories of the Several Regiments and Battalions from North Carolina in the Great War 1861–'65* as a "fine disciplinarian and did much before his untimely death in 1863 in qualifying the regiment for the ordeals through which it had to pass along its subsequent to march to imperishable renown." Morehead died in Martinsburg, Virginia, of typhoid fever. He was described as "a gallant officer" and a "noble and generous hearted man." Below is the gravestone of Morehead and his wife, Susan. The motif in the top center of their gravestone depicts a man's hand clasping a woman's hand. The clasped hands signify closeness on Earth as well as Henry in Heaven reaching down to lead his loved one to him. Their daughter, Minnie, is buried nearby.

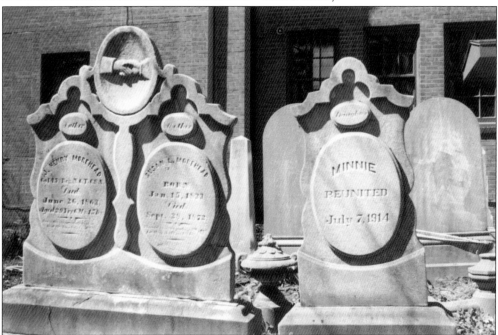

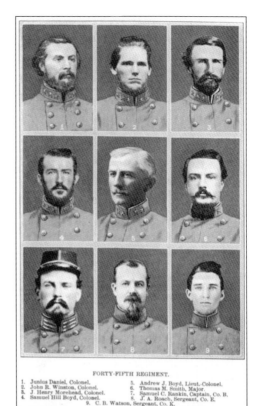

Pictured above are the following members of the 45th North Carolina, from left to right: (first row) Samuel C. Rankin, J. A. Roach, and C. B. Watson; (second row) Samuel Hill Boyd, Andrew J. Boyd, and Thomas M. Smith; (third row) Junius Daniel, John R. Winston, and J. Henry Morehead. At one point, the regiment had three of James T. Morehead's sons on the roster. The Guilford Light Infantry, known as Company C of this regiment, was from Guilford County. Robert Lindsay (1831–1876), son of James T. Morehead, was discharged from the company in 1863 after receiving a vaccination while in the service that sickened him with rheumatism and neuralgia. He is buried near family members in First Presbyterian Church Cemetery.

FORTY-FIFTH REGIMENT.

1. Junius Daniel, Colonel.
2. John R. Winston, Colonel.
3. J. Henry Morehead, Colonel.
4. Samuel Hill Boyd, Colonel.
5. Andrew J. Boyd, Lieut.-Colonel.
6. Thomas M. Smith, Major.
7. Samuel C. Rankin, Captain, Co. B.
8. J. A. Roach, Sergeant, Co. E.
9. C. B. Watson, Sergeant, Co. K.

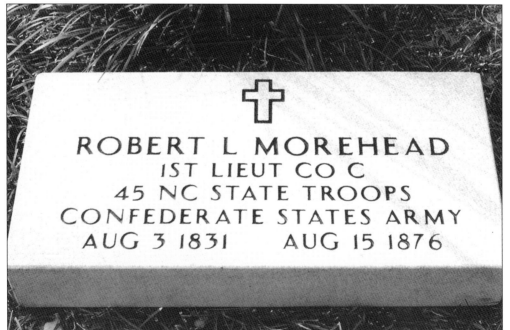

✝
ROBERT L MOREHEAD
1ST LIEUT CO C
45 NC STATE TROOPS
CONFEDERATE STATES ARMY
AUG 3 1831 AUG 15 1876

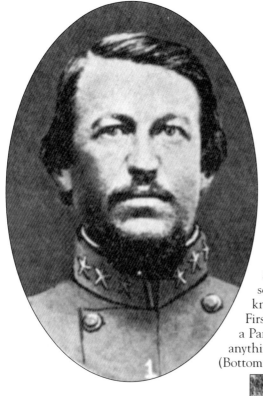

At the Battle of Upperville, in Virginia on June 21, 1863, Peter Gustavous Evans of the 63rd North Carolina State Troops convinced his commanding officer, Gen. Zebulon Stuart, to allow him to lead the charge. Peter was mortally wounded, captured, and taken to a field hospital, which was actually a barn. He died at Stanton General Hospital in Washington, D.C., and was buried in Rock Creek Graveyard. The undertaker was paid $3.30 in U.S. money and $100 in Confederate script for fees involved in the burial. It is not known when his body was returned for burial in First Presbyterian Church Cemetery. Evans was a Partisan Ranger. If this group of men captured anything valuable, it became their personal property. (Bottom: RC.)

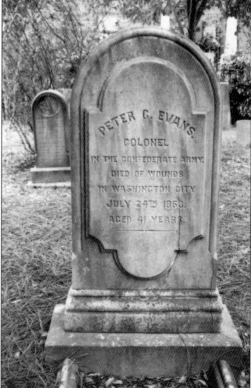

This image of members of the 63rd North Carolina depicts Peter Evans in the center of the picture. Clockwise, beginning above Evans, are James H. McNeill, J. Turner Morehead, James Kirkpatrick, F. R. Rose, James D. Nott, and John M. Gallaway. By order of the Adjutant General's Department, the 5th North Carolina Calvary became the 63rd North Carolina regiment. Shown below is Evans's military marker, erected in 1956. Morehead was a brother-in-law of Evans. When Evans was mortally wounded, Morehead was slightly wounded, but later in the year, Morehead was struck in the mouth by a bullet.

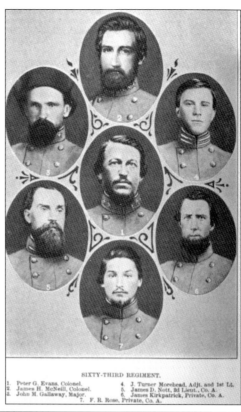

SIXTY-THIRD REGIMENT.

1. Peter G. Evans, Colonel.	4. J. Turner Morehead, Adjt. and 1st Lt.
2. James H. McNeill, Colonel.	5. James D. Nott, 2d Lieut., Co. A.
3. John M. Gallaway, Major.	6. James Kirkpatrick, Private, Co. A.
	7. F. R. Rose, Private, Co. A.

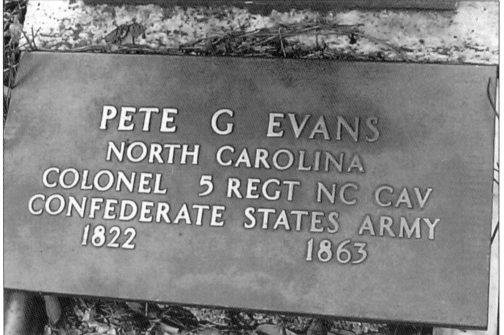

PETE G EVANS
NORTH CAROLINA
COLONEL 5 REGT NC CAV
CONFEDERATE STATES ARMY
1822
1863

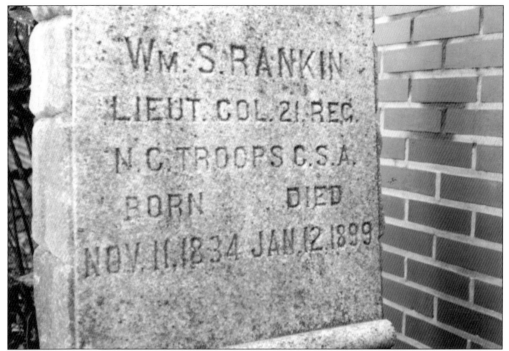

Lt. Col. William S. Rankin of the 21st North Carolina was wounded in the abdomen and thigh and taken prisoner on the first day of fighting at Gettysburg on July 1, 1863. He would remain in a Northern prison at Johnson Island, Ohio, until after the surrender. Rankin is buried beside his wife, Mildred, in the Dick family plot.

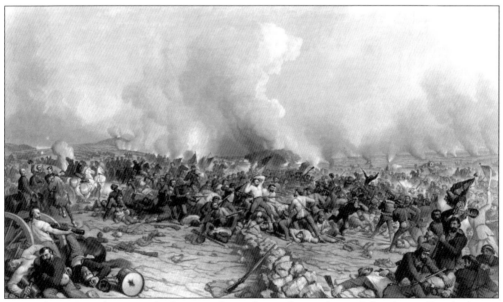

Pictured is a scene depicting the horrors of men dying, the smoke, and the chaos of battle during the fighting at Gettysburg. It is not known how long Rankin suffered on the battlefield before receiving medical aid. (LOC.)

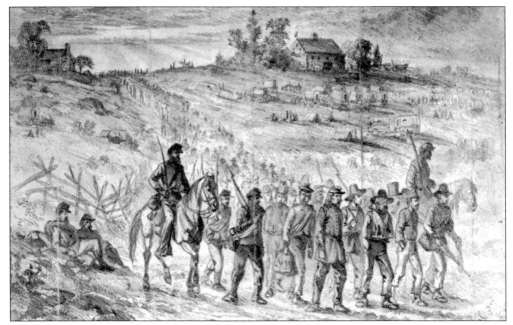

Pictured are captured Confederate soldiers being marched to the rear after the Battle of Gettysburg on July 3, 1863. Col. James Turner Morehead (1838–1919) of the 53rd North Carolina was a son of James T. and Mary Morehead. He was wounded at Spotsylvania, Virginia, and at Gettysburg. Later he was captured at Hare's Hill in Virginia and imprisoned until the end of the Civil War. (LOC.)

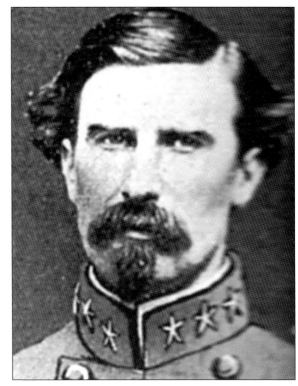

James Turner Morehead was elected to the House of Commons in 1866 and served as senator in 1872 and 1875. Inscribed on his marker is 1 Thessalonians 4:16: "The Lord himself shall descend from heaven with a shout, with the voice of the archangel, and with the trump of God: and the dead in Christ shall rise first."

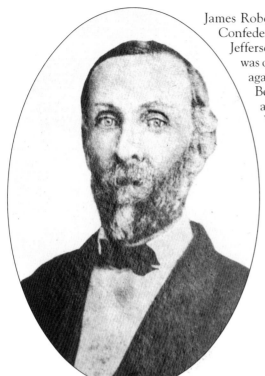

James Robert McLean (1823–1870), a member of the Confederate Congress from 1862 to 1864, supported Jefferson Davis, president of the Confederacy. He was on the Committee of Foreign Affairs and voted against anything that opposed Davis's policies. Before the Civil War, as an attorney, he formed a partnership with Cyrus P. Mendenhall and W. S. Hill to form the law firm of Mendenhall, McLean, and Hill. (UNC.)

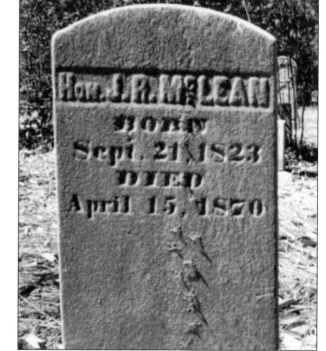

After the war, McLean's health was weakened. His wife, Narcissa Jane (1834–1873), a daughter of W. R. Unthank of the Quaker faith, was of the Episcopal faith. She is buried beside her husband. Shown at right is James Robert McLean's tombstone.

Fight Between Rebels and Union Citizens— at Greensboro', N. C.— Defeat of the Rebels —The Army of the Potomac.

FORTRESS MONROE, Aug. 26.

Reliable information has just been received here from Roanoke Island, under date of the 24th inst., that a rebel force commanded by Major Whitford and Capt. Keyoe, went to Greensboro', N. C., for conscripts for the Rebel army, and that the Union citizens turned out in force to resist the conscription. A severe fight ensued, and the Rebels were driven from Greensboro'. Many of them were killed and wounded. Capt. Keyoe was killed, and Major Whitford mortally wounded.

All is quiet along the lines of the army of the Potomac.

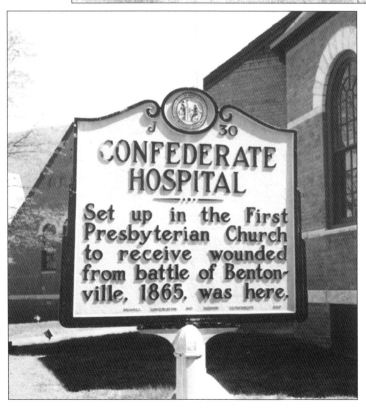

CONFEDERATE HOSPITAL

Set up in the First Presbyterian Church to receive wounded from battle of Bentonville, 1865, was here.

This article from the *New York Tribune* dated August 1864 relates that when the rebels attempted to recruit men for the shrinking Confederate ranks, the Unionist citizens of Greensboro attacked them, killing one and injuring another. The citizens of Greensboro were war weary, starving, and broken hearted by this time. The starving women attacked the Confederate supplies stored in Greensboro. They stopped only at the threat of being shot. At left is a roadside marker showing the location of the First Presbyterian Church building used as a hospital after the battle of Bentonville in 1865.

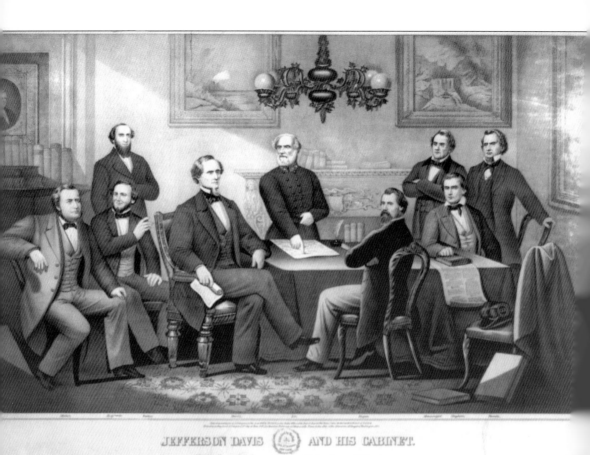

JEFFERSON DAVIS AND HIS CABINET.

Pres. Jefferson Davis, Gen. Robert E. Lee, and members of the Confederate cabinet are pictured in the scene above. Davis, Secretary of the Navy Stephen R. Mallory, Secretary of State Judah P. Benjamin, Secretary of the Treasury George A. Trenholm, Attorney General George Davis, Postmaster General John H. Reagan, and Secretary of War John C. Breckinridge arrived in Greensboro, which served as the capital of the Confederate States for five days in the closing days of the Civil War. (LOC.)

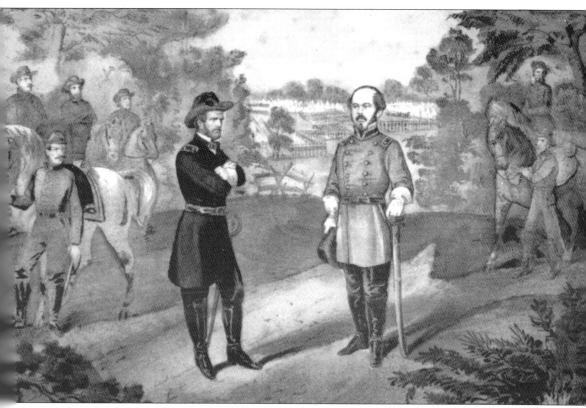

Gen. Joseph Johnston surrenders his troops near Greensboro in 1865. The citizens of Greensboro were quite excited by these events happening so near them. There was fear of invasion as well as awe at seeing Confederate leaders in town. The townsfolk offered shelter to the many refugees who fled their homes from the eastern portion of North Carolina in fear of the invading Northern army. (LOC.)

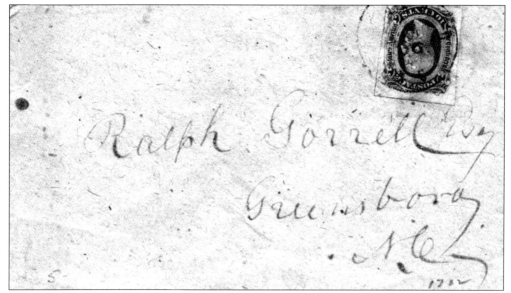

This envelope, addressed to Ralph Gorrell in Greensboro, bears a 10¢ stamp that has been placed upside down on the cover. The stamp has a picture of Jefferson Davis, president of the Confederacy. "Confederate States of America" is written on the stamp. Below is the home of Ralph Gorrell, a place of antebellum celebrations. (Below: GPL.)

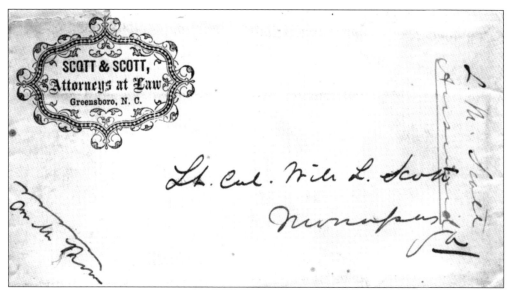

This cover, addressed to Lt. Col. William L. Scott at Manassas, Virginia, is from his brother Levi. Below Levi's name on the right side is the word "Answered." On the lower left side is written "On the Run." The upper left side has his law office's logo. William's obituary states he was buried in First Presbyterian Church Cemetery. Today his burial location is unknown. William served as mayor of Greensboro immediately following the Civil War. William, depicted in this picture, was an attorney and teacher before he died in 1872. (Right: GHM.)

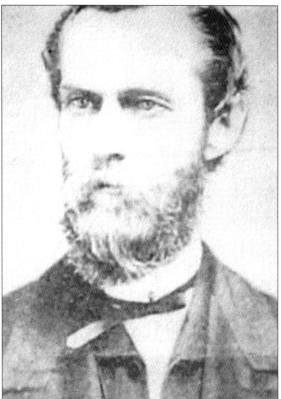

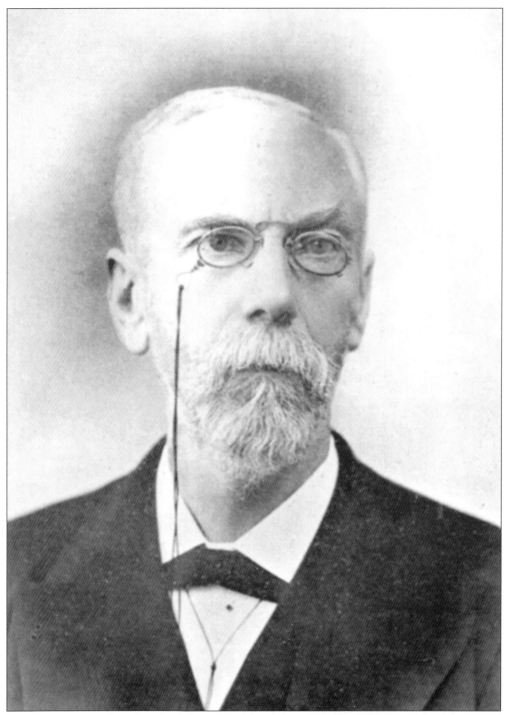

Levi Scott is remembered as the father of the Greensboro Bar. His office would be the scene of Gov. Zebulon Vance's last official proclamations after Vance fled the capital in Raleigh. Scott is buried in Greenhill Cemetery, but amongst the old stones in First Presbyterian Church Cemetery, one may find the names of his parents, siblings, wife, and daughter.

The weatherworn gravestone of Julia Gilmer keeps secret the turmoil she endured during the Civil War. When the war ended, soldiers under the command of Gen. Jacob D. Cox occupied Greensboro. Gilmer was requested to entertain Cox's wife. Author Burton A. Konkle stated, "Gilmer flatly told her husband that she refused to add one more spectator to the pageant, for it was an enemy's bullet, which had maimed her only son for life."

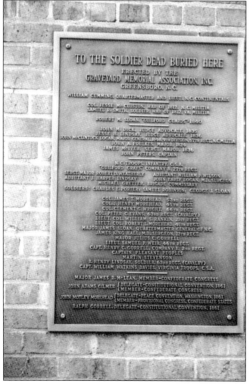

Mounted on the outside wall of the Greensboro Historical Museum is a memorial erected by the Memorial Association of Greensboro listing the names of the veterans buried in the First Presbyterian Church Cemetery. Col. Jesse McCuiston, Michael Gretter, Samuel Robinson, Capt. Pleasant Peoples, and Martin Stevenson, listed on the memorial, do not have tombstones in the cemetery.

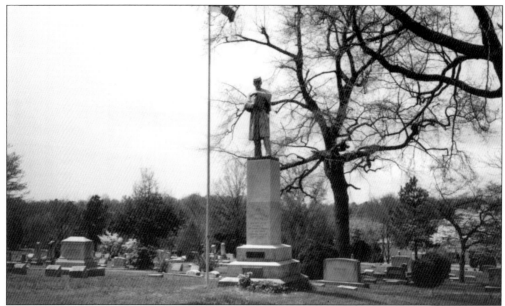

Hundreds of wounded and sick troops arrived by train in Greensboro in 1865. The town was overwhelmed, and every resource available was used to aid these dying men. Over 300 men suffered and died without anyone ever knowing their names. It is rumored these men were buried in the First Presbyterian Church Cemetery, as well as several locations throughout town. After the war, the bodies were exhumed and interred in Greenhill Cemetery. Shown is the memorial marker erected in honor of the unknown war dead at Greenhill Cemetery. Women of Greensboro, many of whom found their final resting place in the First Presbyterian Church Cemetery, led the movement to give these men a decent burial.

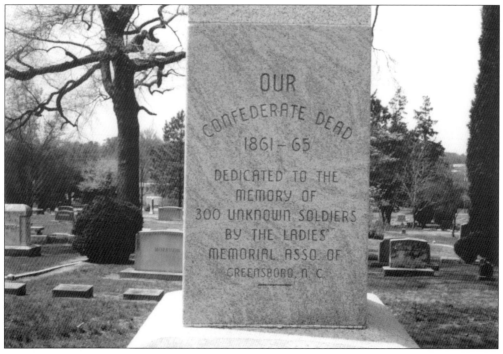

Three

19TH-CENTURY LIFE

The early citizens of Greensboro valued education. This 1859 commencement cover of the University of North Carolina lists Samuel P. Weir as a member of the Dialectic Society. Of the six editors, four would be dead by the end of the Civil War. The impact of the Civil War on 19th-century life was devastating. Interred in the First Presbyterian Church Cemetery are graduates, trustees, and benefactors of the University of North Carolina. There is only one known adult interred in the cemetery listed on the census records as unable to read or write. (DOC.)

Edgeworth Female Seminary was founded by John Motley Morehead with classes first held in 1840. The institution was named in honor of Maria Edgeworth, one of Morehead's favorite authors. Today a YMCA exists on the former grounds of Edgeworth. As a parent, Morehead saw the need for quality female education in the South and used his own funds to build Edgeworth. (GHM.)

Mary Ann Hoye (1809–1844) was a former teacher of the Greensborough Female Academy established by Reverend Paisley and run by his daughter, Polly. Hoye was a beloved principal of Edgeworth Female Seminary. She died during the 1840s fever epidemic. Her monument has a memorial wreath motif.

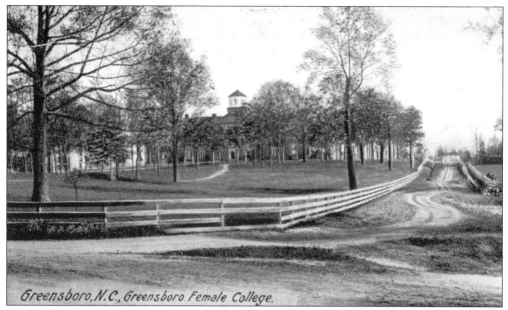

Greensboro, N.C., Greensboro Female College.

Classes at Edgeworth were extensive, with offerings in spelling, reading, writing, grammar, geography, rhetoric, composition, arithmetic, algebra, geometry, astronomy, philosophy, mineralogy, botany, chemistry, music, foreign languages, needlework, drawing, and painting. Edgeworth appears to have served as a preparatory school for later college study. Social activity in the schools consisted of essay reading, musical performances, and activities such as 'possum suppers. Buried in the graveyard are the founder, the principal, and many of the teachers and students who lived and learned together at Edgeworth, as well as graduates and teachers of Greensboro Female College. Shown are two images of Greensboro Female College, chartered in 1838 under the leadership of Rev. Peter Doub. The school, known today as Greensboro College, is now a coeducational institution existing in its original location.

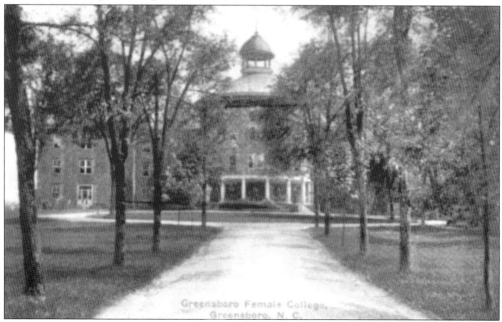

Greensboro Female College,
Greensboro, N. C.

West Market Street Methodist Church was founded in 1830. In the early history of Greensboro, the Methodists and Presbyterians took turns having church services at the Paisley Male Academy until church buildings were built. Through time, as needs arose, the two religions shared their buildings with one another. Several individuals of the Methodist faith are interred in the First Presbyterian Church Cemetery.

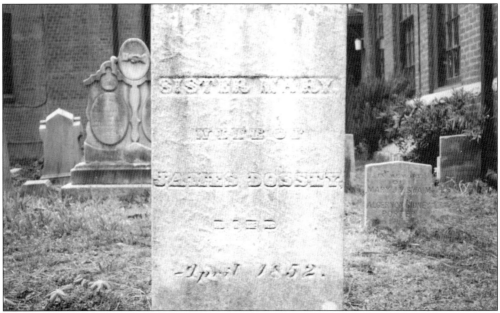

Mary Dossey, wife of James, died on May 1, 1852. Dossey was a member of the Methodist Church. Her obituary in the *Patriot* on May 8, 1852, states that she has gone to join a devoted husband and a lovely family of children in the realms of light and joy above: "Be thou faithful unto death and I will give thee a crown of life."

C. D. Q. College Class, Helpers Committee,
West Market Street M. E. Sunday School,
Greensboro, North Carolina.

The Methodists' first church building was completed in 1831 on South Elm Street. A cemetery known as the Old Methodist Cemetery was removed to Greenhill Cemetery. The removal of inner-city cemeteries was quite common due to the growth of the city and escalating property values. Another reason often overlooked for the removal of early cemeteries was health concerns. In the 1920s, the First Presbyterian Church Cemetery was threatened with removal. Church members and townspeople rallied around the old cemetery and saved it from removal. These postcard images of women posing in front of the Methodist Church reflect clothing styles of the early 20th century.

C. D. Q. College Class, West Market Street
M. E. Sunday School, Greensboro, North
Carolina.

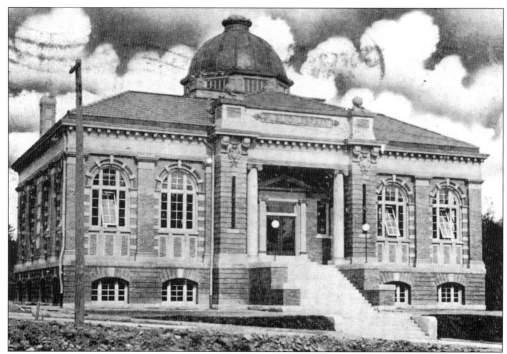

Shown is a postcard image of Carnegie Public Library, established in 1909. Antebellum Greensboro was progressive in their views on education of those in bondage. Many slaves and free African Americans were taught skills in carpentry shops, tin shops, cotton mills, and sawmills in an attempt to aid them in becoming self-sufficient and also in preparation of future emancipation for those in bondage. Basic arithmetic was taught. There is evidence that people secretly taught those enslaved to read. Known burial locations of African Americans in Guilford County are scarce before the opening of Union and Maplewood Cemeteries.

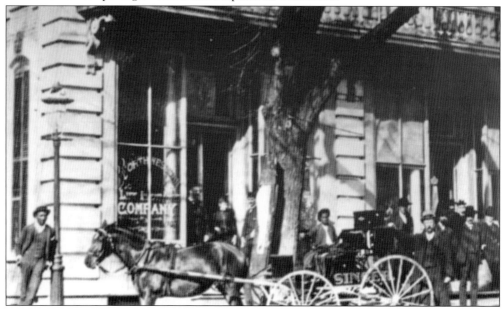

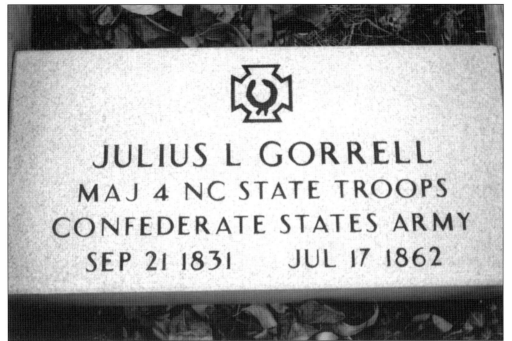

JULIUS L GORRELL
MAJ 4 NC STATE TROOPS
CONFEDERATE STATES ARMY
SEP 21 1831 JUL 17 1862

Julius Lafayette Gorrell (1831–1862) was quite popular with the belles of Greensboro, given the number of valentines and invitations received and offered by the young ladies that are still in existence. Gorrell was active in initiating "Y" programs at Greensboro Female College and in 1859 became the first president of the YMCA in Greensboro in conjunction with the First Presbyterian Church. Due to the Civil War and economic conditions, the first YMCA would not be built until the early 20th century. Gorrell, an attorney, was in the North Carolina House of Representatives in 1860. Shown below is the YMCA.

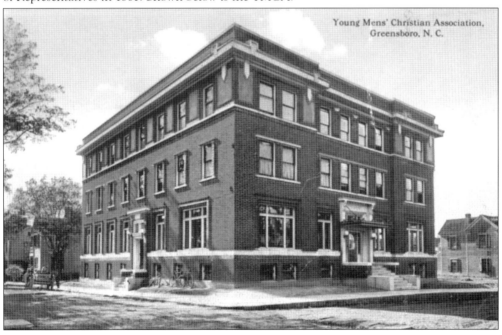

Young Mens' Christian Association, Greensboro, N. C.

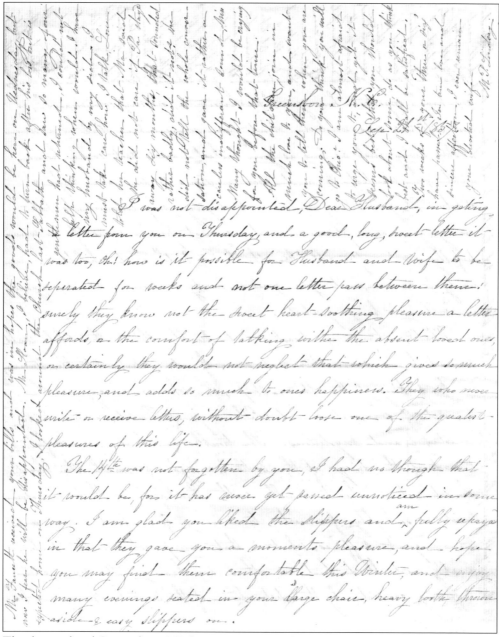

This letter, dated September 1857 from Marianna to her husband, Robert G. Lindsay, gives insight into daily home life in early Greensboro. "I wonder, Dear husband, how you are just now engaged and just look into your house and see how lonesome wife looks sitting in her gown, a cape thrown around her, by a nice little fire, four little ones spread out upon a pallet, and Lettie in your bed. The nine o'clock bell ringing and Roscoe is keeping his unpleasant howling time with it." In the letter she tells her husband local news and speaks of the *Central America* sinking off the coast of North Carolina. Of the event she says, "The ways of Providence are truly wonderful and mysterious." Children of the couple—Kate Austin, Emma Perry, and Charlotte—are buried in the First Presbyterian Church Cemetery.

Emma Perry (1857–1859) was born two months after the writing of the letter. Carved on her gravestone are the words "Weep not for me! When a few swerving years have flown for I will meet thee at heaven's gate and lead thee on. Weep not for me!" Emma's sister Kate is buried beside her. Carved on Kate's marble stone are the words "It is thy grave! Fare thee well our darling till the Resurrection morn." Shown below are the graves of Charlotte or "Lottie" (1845–1876) and her husband, Alexander M. Peyton (1838–1876). Charlotte died one month after her husband on the same deathbed he laid upon in his final days.

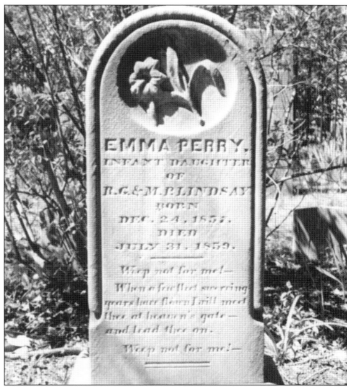

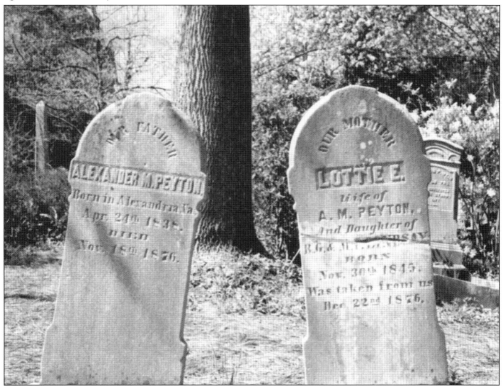

Macadam Road near **Greensboro, N. C.**

This postcard view of a macadam road offers insight into early transportation problems in North Carolina. After rain and wintry conditions, the roads often were muddy, with large potholes. In dry conditions, dust was a problem. In the early days of Greensboro, residents were required to work the roads, and a large majority of those early road crews are buried in the First Presbyterian Church Cemetery. Shown below is an early scene in Greensboro displaying the latest mode of transportation, a buggy.

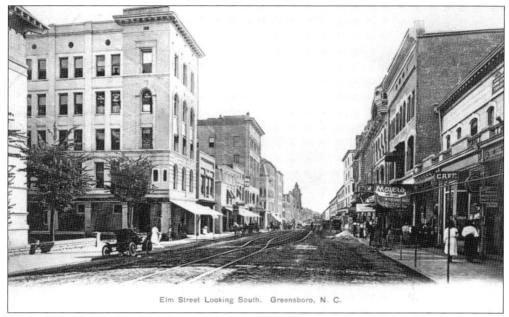

Elm Street Looking South. Greensboro, N. C.

This postcard, published before 1907, depicts Elm Street and an early automobile. Shown below in a postcard image of Elm Street, the city has erected power lines and street lighting. The trolley system was a boon to transportation, enabling people to live greater distances from town. Before the advances in transportation, the arrival of the stagecoach in town was cause for excitement.

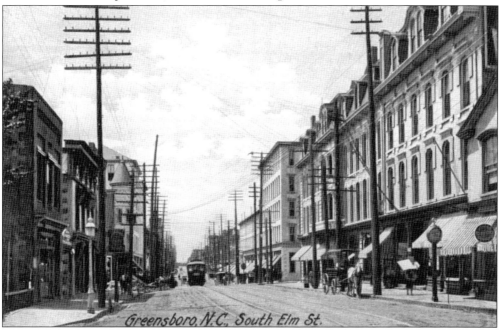

Greensboro, N.C., South Elm St.

This scene of Elm Street during the 1880s depicts the men of Greensboro viewing one another's livestock. Notice the men's clothing styles and their hats. Early trade was often carried out in the middle of the street, especially during court days. Livestock roamed the streets of Greensboro until the 1870s. Immediately after the Civil War, Greensboro's streets were in poor condition. Mayor William Lafayette Scott employed recently emancipated slaves to repair the streets. Shown below is Asheboro Street looking south.

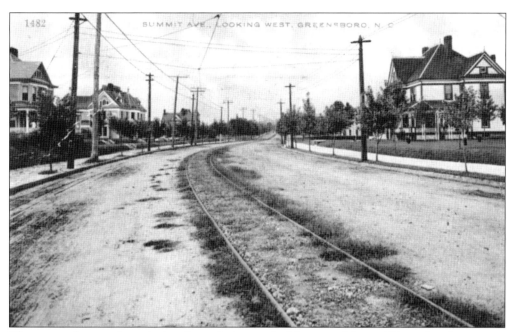

The postcard scene above depicts Summit Avenue looking west. Many of Greensboro's streets to this day bear the same names as those inscribed on the monuments in the First Presbyterian Church Cemetery. The greatest advancement in transportation came to Greensboro with the completion of the railroad in 1856. The scene below depicts trains from the 19th and 20th centuries. The citizens of Greensboro were extremely mobile given the limitations in transportation.

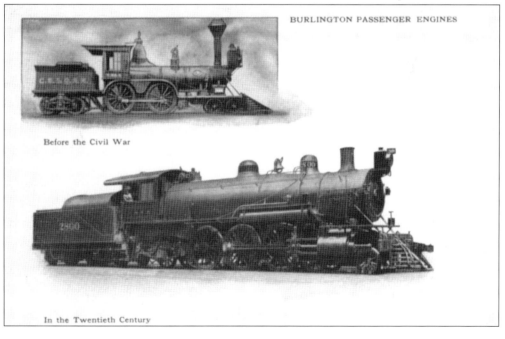

BURLINGTON PASSENGER ENGINES

Before the Civil War

In the Twentieth Century

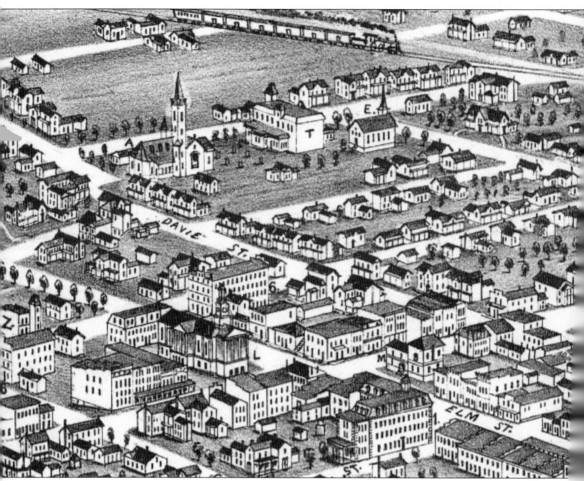

This scene, enlarged from an 1891 map of Greensboro, shows the growth of the town since 1808. The letter A marks the location of the First Presbyterian Church, the letter T marks the location of the graded school, and the letter E marks the location of the Catholic church. The courthouse is located by the letter L. Notice the train at the top of the map. The First Presbyterian Church Cemetery is located between the church and school. (LOC.)

Pictured here are members of the Mebane family, though individual names are not known, and it is not known if they are indeed members of the Mebane family interred in this cemetery. The picture is an example of history that is lost due to a lack of documentation. The picture serves to show hair and clothing styles of gentlemen. Supposedly their shirt collars were made of paper. The ladies are dressed in bonnets and are clothed completely, in keeping with 18th- and 19th-century styles and rules of modesty. (UNC.)

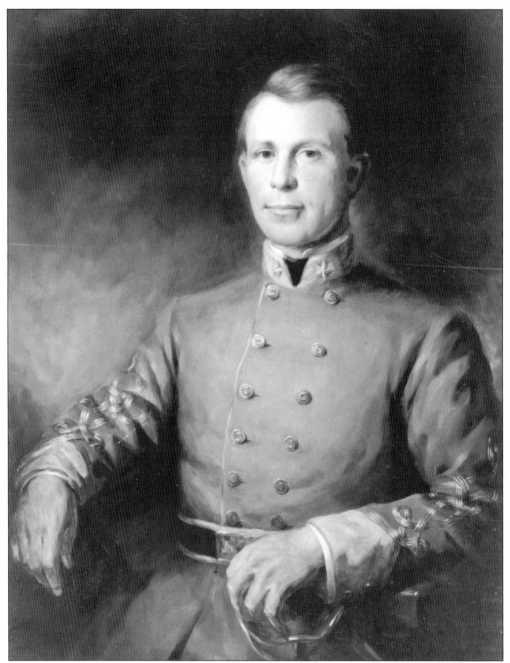

James Turner Morehead serves as an example of family members being named after one another. Though there are two men named James Turner Morehead buried in the First Presbyterian Church Cemetery, this Morehead is not one of them. People named their children after grandparents, after previous children who had died in the family, after friends, and famous people. The habit of naming loved ones in such a way was, and still is, popular throughout the South during the 19th century, thus adding confusion for the modern-day researcher and genealogist. (UNC.)

The Greensborough Patriot.

James A. Long (1819–1864), seen in 1859, was an editor of the *Greensboro Patriot*. In the 19th century, dueling was used as a means to settle disputes amongst gentlemen. Long was challenged to a duel. He manfully stated in the paper that he was not about to engage in mortal combat because of printing the truth. Readers could label him a coward, but he had a family to support.

Shown is the Long family plot. The cemetery consists of many family plots. It was popular in 19th-century Greensboro to enclose family plots with edging or fencing depending on the wealth of the family. There are many examples of plots outlined with ordinary rocks and brick. The Long family gravestones have fallen and are covered with soil.

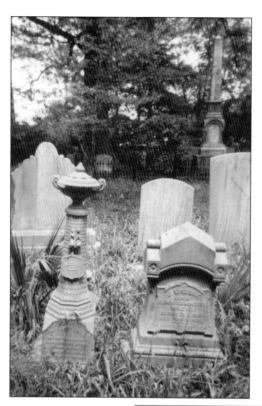

This older scene of the cemetery depicts in the background one of the huge trees destroyed by an ice storm. In the foreground are the graves of Nettie and J. Lindsay, children of Clement and Annette L. Wright. Their monument inscriptions face west, while the Morehead monuments directly behind them have inscriptions facing east. Markers in the cemetery are also orientated facing north or south.

Capt. John Peters's monument states that he was a native of Cornwall, England. In the graveyard, carved upon the ancient stones, one will find immigrants proudly stating their heritage. Though many of the deceased were in the Piedmont section of North Carolina for several generations, the stones tell of the migration from Scotland, Ireland, and England, with several second-generation Germans.

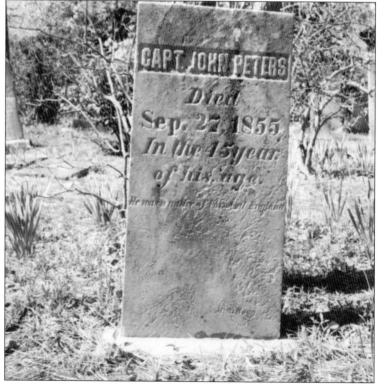

NOTICE.
Greensboro' N. C., Dec. 29, 1860.

Be it Ordained by the Board of Commis-sioners of the Town of Greensborough, That all persons from the city of Columbia, S. C., or from any other place in the State, or any adjoining State, infected with Small Pox, are prohibited from coming into the town of Greensboro', under a penalty of $50, to be collected from any person in such case offending. And if any person from any place so infected, and not being informed of this ordinance, shall come into the town of Greensboro', he shall be required to depart immediately, under penalty of $10 for every hour he shall stay after being informed.

This Ordinance to be in force until the dan-

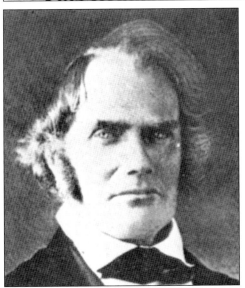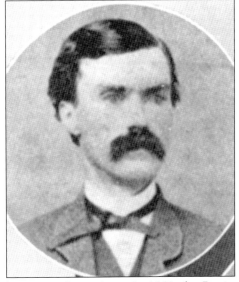

Disease was common amongst the citizens of 19th century Greensboro. In 1860, the *Patriot* warned people infected with small pox not to enter Greensboro. Anne (1831–1834), Martha (1830–1834), and Robert (1833–1834), children of John M. and Elizabeth Logan, died with scarlet fever. A poem that speaks of the parent's great heartache was found in a family Bible and might have been written by their children's mother, Elizabeth. "I sought at twilight's pensive hour the path which mourners tread, where many a marble stone reveals the city of the dead. The city of the dead where all from feverish toil repose; while round their beds the simple flowers in sweet profusion grow." Shown are the children's father, John McClintock Logan, on the left and their brother, John Early Logan, on the right. (Top and bottom right: GHM; bottom left: GPL.)

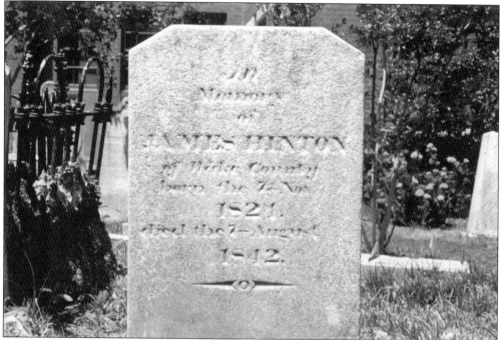

The story of the Logan children has become a part of the oral history of Greensboro. Leading causes of death from disease in this cemetery included consumption, small pox, scarlet and typhoid fevers, dropsy, pneumonia, and the 1840s fever epidemic. Shown above is the gravestone of James Hinton (1824–1842) of Wake County. He was a student at Caldwell Institute, which closed due to the fever epidemic in Greensboro. Shown below is the gravestone of Mary Pen, who in 1844 died from consumption.

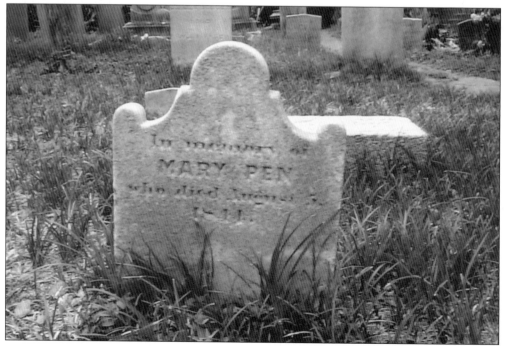

Death was a part of life in 19th-century Greensboro. David Brainard Houston (1820–1856) accidentally fell into a flywheel at a steam sawmill. He was crushed to death in one of Greensboro's early industrial accidents. The Masonic Lodge in which he was a member published a tribute of respect stating they would wear the usual armbands as a symbol of respect and that they recognized the divine voice of Providence calling upon them to "be ye also ready for in such an hour as ye think not the Son of man cometh" (*Greensboro Patriot*). The cemetery has many tragic tales of misfortune carved upon its marble stones. A headline in the *Patriot* newspaper dated February 7, 1846, details the heartache of the Watson Wharton family with the headline "A Lost Child." The child's body was found the following week in a millpond.

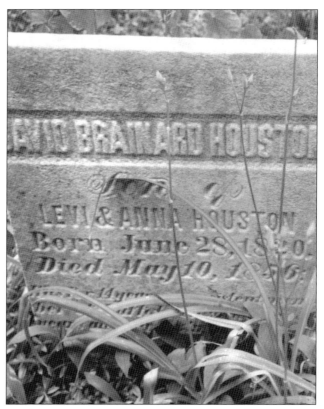

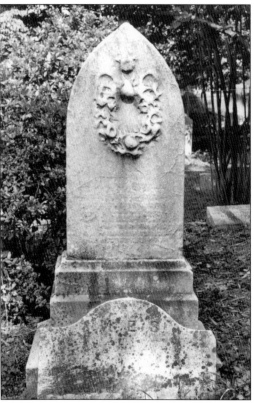

Mary Eliza Weatherly Scott (1825–1869), injured from falling out of a rockaway (buggy), tried to comfort her mother from her deathbed. "Mother, some years ago while you lived at Woodside, I can't describe the happy feelings I used to have in view of a visit out there with my children and Mr. Scott. I have thought at such a time those moments of waiting and expectation to be followed by seeing father and mother and brothers and sisters, at the dear home, were as sweet and delightful as any I ever enjoyed, and mother, I feel just that way now, my trunk is packed and all is ready and I am waiting to go to my Father's house, to my eternal home." Shown is Mary's weathered monument.

Mary's mother, Margaret Gillespie Weatherly, (1816–1872) led a life in 19th-century Greensboro centered on her home, family, and church. She is buried beside her husband, Andrew (1810–1877), mayor of Greensboro in 1862. Carved on her monument in the Weatherly family plot are the words "Oh the lost, the unforgotten/ Tho the world be oft forgot/ Oh the shrouded and the lonely/ In our hearts they perish not." (FPCA.)

Mary Gilmer Shober (1833–1858), wife of Charles, died due to complications of childbirth. The town celebrated on hearing the news that Mary had given birth. Shortly afterward, Mary's family and friends were heartbroken to learn that Mary was deathly ill. Mary's baby daughter survived her. Childbirth took many a young mother's life in 19th-century Greensboro. Shown is Shober's monument.

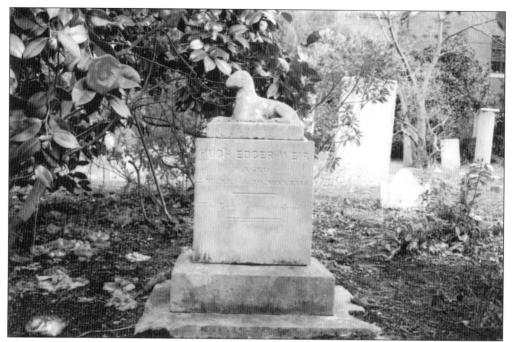

The high rate of infant mortality in 19th-century Greensboro is told by the many small gravestones in the cemetery. Shown is the monument of Hugh Edgar Weir (1850–1853). The lamb is a popular mourning symbol on children's markers. Inscribed on Hugh's marker are the words "The Lord is my shepherd." Concil Tyer (1776–1875) enjoyed the longest life of those interred in the First Presbyterian Church Cemetery.

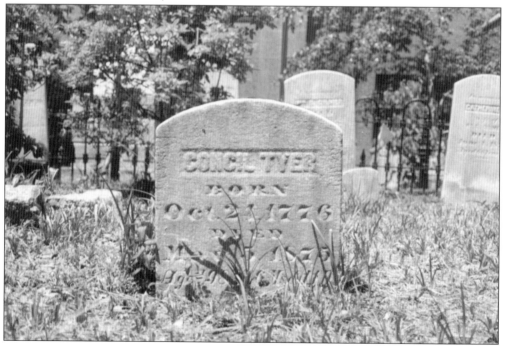

The townspeople of Greensboro enjoyed attending the circus when it came to town. The Robinson Circus boasted that their bareback riders were the best in the world, performing somersaults with ease. A little girl performing for the circus was fatally injured. Her broken body was interred in the First Presbyterian Church Cemetery in an unmarked grave. The legend of the little girl is told in Greensboro to this day. Long ago, children maintained the little performer's grave. Today her burial location is unknown. Common fieldstones were used to mark several of the early graves in the First Presbyterian Church Cemetery.

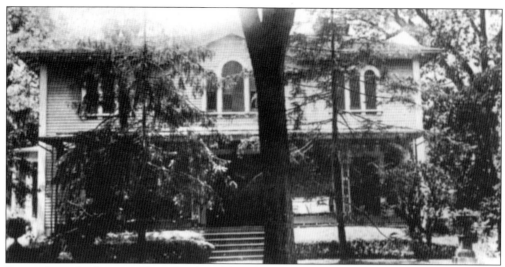

Pictured are the homes of Jesse Lindsay (above) and Jed Lindsay (below). Social life in 19th-century Greensboro often consisted of inviting guests into the home to dine, have conversation, and to play games, particularly games allowing touch. The young courting folks of Greensboro enjoyed a game in which one participant was blindfolded and seated upon the lap of another. The blindfolded person was successful if he guessed correctly without touching whose lap he was sitting upon. If correct, he was allowed to remove the blindfold. If not, he had to continue playing while the other players placed pillows or other items on their laps to confuse him.

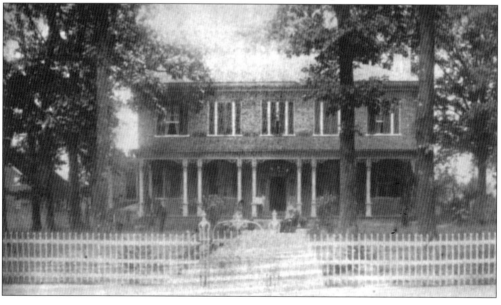

Four

FLOWERS IN THE GARDEN

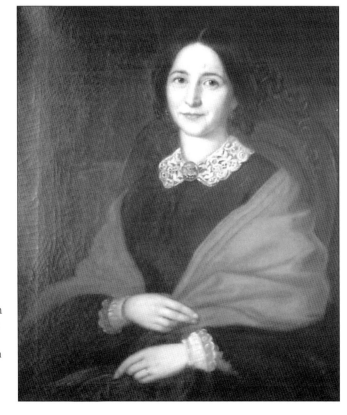

This is a picture of a painting of Anna Eliza Morehead Evans (1828–1876), currently hanging on a wall at Blandwood, her childhood home, doesn't fully depict her beauty or the talent of William Garl Browne, the artist. Anna is the daughter of John M. Morehead. She graduated from Edgeworth Female Seminary. Anna married Peter Evans in 1850. (BM.)

Shown above is Anna Evans's monument. Four of Anna Evans's children—an unnamed infant, a daughter, Louise (1854–1861), and twins Peter Chalmers (1857–1858) and John, who share a gravestone—are buried nearby. John died on Christmas day in 1862. Seven months later, Evans would learn of her husband's death in the Civil War. The bird motif below is carved upon the twins' gravestone: "Two little birds immortal winged/ Once by our Father's love was given /One nestles on our bosoms still/ The other waits for us in Heaven."

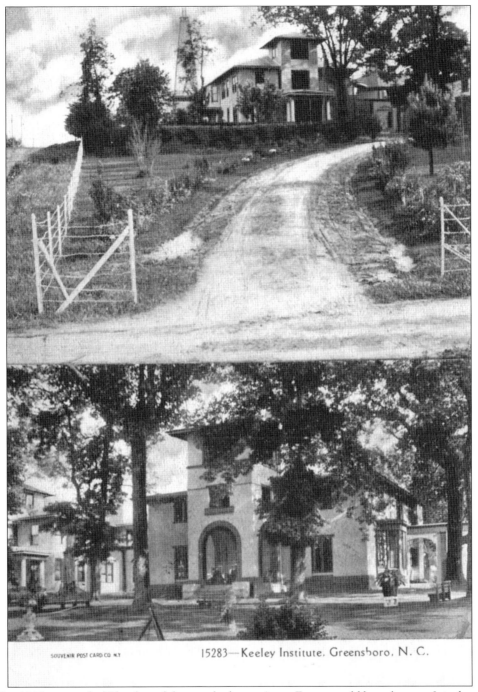

SOUVENIR POST CARD CO. N.Y 15283—Keeley Institute. Greensboro, N. C.

This 1907 postcard of Blandwood depicts the home Anna Evans would have known. It is shown here when it was the Keeley Institute, a treatment center for those suffering with drug and alcohol addictions. The house is now a museum. It is located on Washington Street in Greensboro. Tours are offered as well as special events throughout the year. In Blandwood, several members of Anna Evans's family are depicted in beautiful paintings by William Garl Browne. The masterpieces are best viewed by a visit to the house museum, as they are truly works of art.

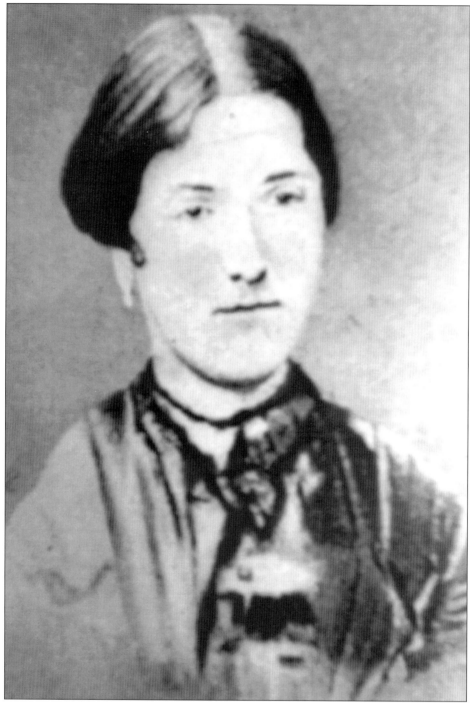

Mary Jane Virginia (1833–1865) is the daughter of William and Abiah Shirley Swaim and the wife of Algernon Sidney Porter. She graduated from Edgeworth Female Seminary and Greensboro Female College. She was a talented writer in her own right when she was struck down at an early age by the deadly disease consumption, but she is better known as the mother of William Sydney Porter (1862–1910) the famous short-story writer who used the pen name O. Henry. (GHM.)

Early in Mary's life, she lived in this house on Friendly Avenue. Still in its original location, it is now on the National Register of Historic Places. Mary's father, William, a newspaper editor, was a member of the Manumission Society of North Carolina and an early abolitionist. He persisted in speaking out on the horrors of slavery and kept the issue foremost in his *Patriot* newspaper. His views were equally progressive in regard to women, of whom he wrote, "Woman is the most important sex—and if but one half of our race can be educated, let it be woman instead of man." Shown is Mary's mother, Abiah Shirley Swaim. Abiah was buried in the Old Methodist Cemetery, which was removed to Greenhill Cemetery. (Right: GHM.)

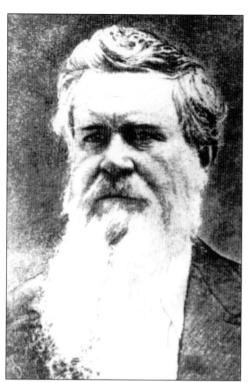

Dr. Algernon Sidney Porter (1825–1889), husband of Mary and father of O. Henry, was a son of Sidney and Ruth Porter. Algernon was a pharmacist, doctor, teacher, and inventor. He often provided medical services without charge if his patients were in need. He was a quiet, gentle man who suffered with rheumatism. (GHM.)

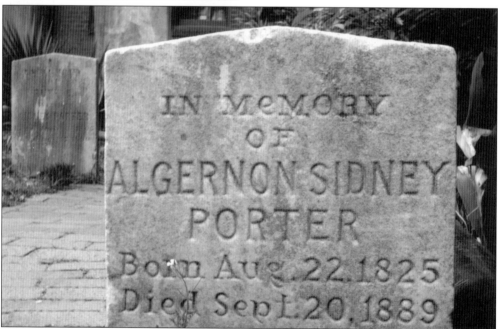

Algernon enjoyed tinkering. He invented a train coupler, thus making a dangerous procedure safer. He was often teased by townsfolk in regard to his inventions. He was on the board of health, regularly making trips around town looking for possible health risks. When a convicted felon was put to death by hanging, Algernon was called upon to sign the death certificate. Shown is Algernon's memorial stone.

Ruth (1805–1890), a daughter of Dr. David and Eunice Gardner Worth, was born in the Centre Community of North Carolina. She is better known as the grandmother of the short-story writer O. Henry, though she was talented in the medical field and quite qualified as a doctor, serving as a midwife to over 2,000 women in the Greensboro area. (GHM.)

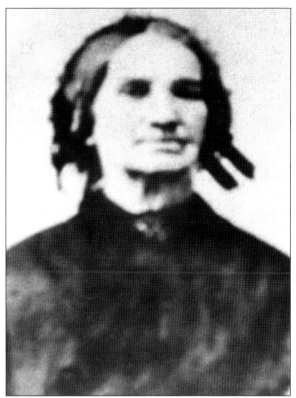

Ruth also treated the sick and wounded Civil War soldiers that arrived in Greensboro in 1865 after the Bentonville battle. Ruth left her Quaker faith, as was required during that time period, upon her marriage to Sidney Porter (1790–1848) in 1824. Sidney, of Connecticut, was a traveling clock peddler for Seth Thomas clocks at the time he met Ruth. Shown below is the Porter family plot.

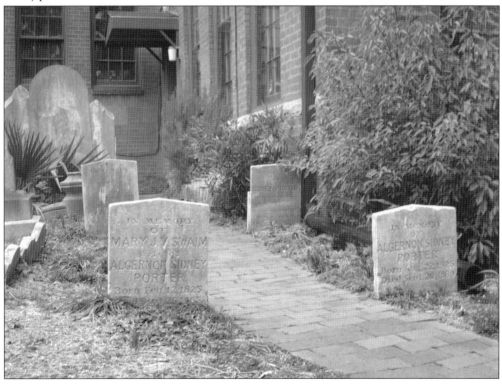

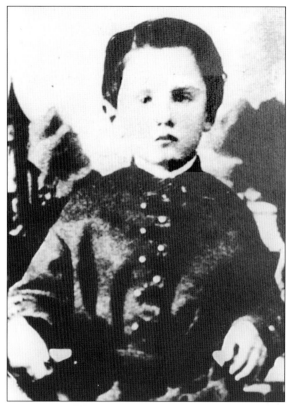

This picture depicts O. Henry as he appeared in his youth in Greensboro. O. Henry had two brothers, Shirley Worth Porter and David Weir Porter. David died in infancy. O. Henry enjoyed pulling pranks and drawing cartoons of the local residents and worked in his uncle's drugstore as a pharmacist. Though he left Greensboro in 1882, he remained in close contact with the citizens. He is honored to this day in Greensboro with reading clubs and yearly plays based on his short stories. O. Henry is interred in Asheville, North Carolina. Shown is the Porter family cradle, on display at the Greensboro Historical Museum. (GHM.)

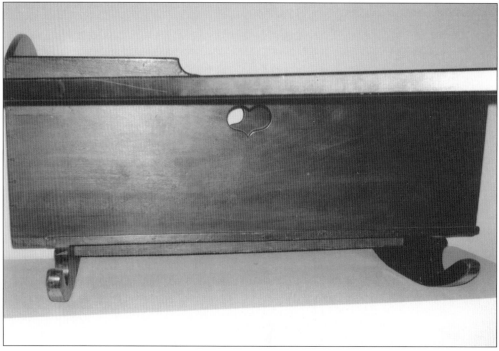

Dr. James King Hall (1816–1885) born in Iredell County, North Carolina, to Richard and Martha Moore Hall, was a close friend of the Porter family and took a special interest in the youthful O. Henry. Hall served as a surgeon in the 22nd North Carolina during the Civil War and, in 1883, was president of the North Carolina Medical Society. In the Hall family plot are his sister, Elizabeth (1809–1881); his wife, Fannie (1826–1913), daughter of Rev. Jesse and Polly Paisley Rankin; and his infant son, Charlie (1863–1864). Shown is Hall's gravestone. (Top: GHM.)

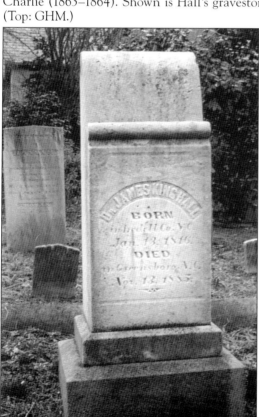

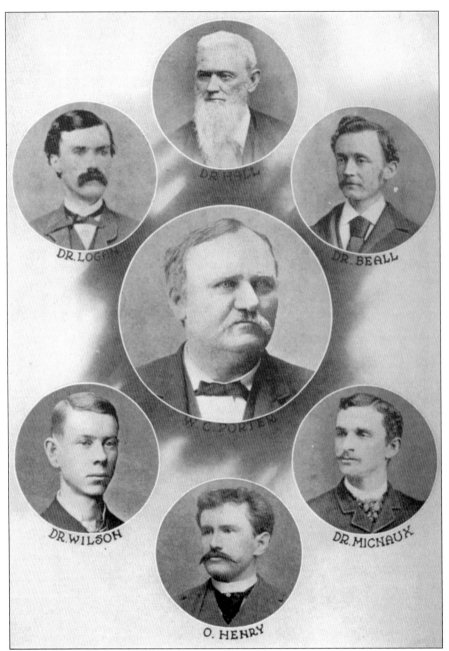

DR. LOGAN

DR. HALL

DR. BEALL

W. C. PORTER

DR. WILSON

DR. MICHAUX

O. HENRY

William Clark Porter's drugstore was a popular meeting place in Greensboro to discuss medical complaints and socialize. O. Henry worked in his uncle's store in his youth. O. Henry managed to frighten Hall after Hall dropped off a urine sample at the drugstore for analysis. O. Henry filled the sample with sugar, convincing Hall his situation was serious. Such mischief was common amongst the youth of Greensboro. This group of doctors and pharmacists were frequent visitors at Porter's drugstore. In the center is the proprietor of the drugstore, William Clark Porter. Clockwise from top center are Dr. James King Hall, Dr. W. P. Beall, Dr. Michaux, O. Henry, Dr. Wilson, and Dr. John Early Logan. Of this group, Hall and Logan are interred in the First Presbyterian Church Cemetery.

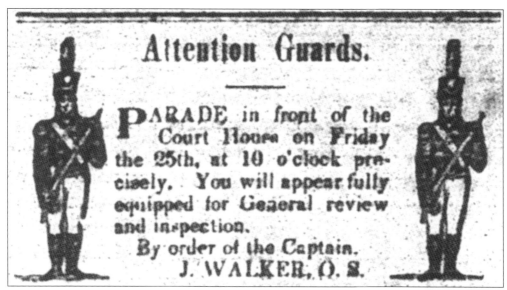

John Early Logan (1835–1912) often led the militia parades in his youth, riding about on his little pony to the delight of the townspeople. John served as a physician during the Civil War. From what can be gleaned from his Civil War letters, he was a humorous, happy personality. Shown above is an early militia advertisement ordering the Greensboro Guards to appear for review. Logan's name marker in the family plot is shown below.

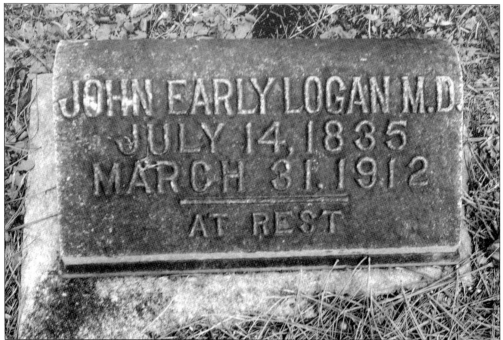

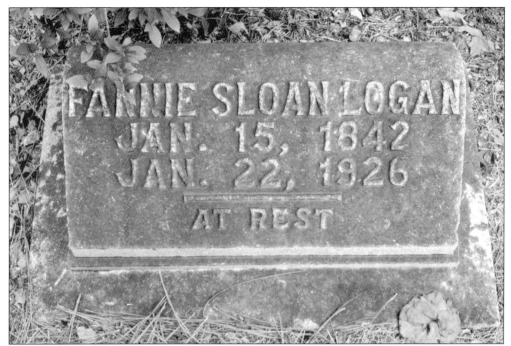

John Early Logan married Frances (Fannie) J. Mebane Sloan (1842–1926), daughter of Robert Moderwell and Sarah Jane Paisley Sloan, in 1868. Fannie lived from birth to death in the same house. She has the honor of being the last person interred in the First Presbyterian Church Cemetery. Shown are Fannie's name marker and the mammoth monument of the couple.

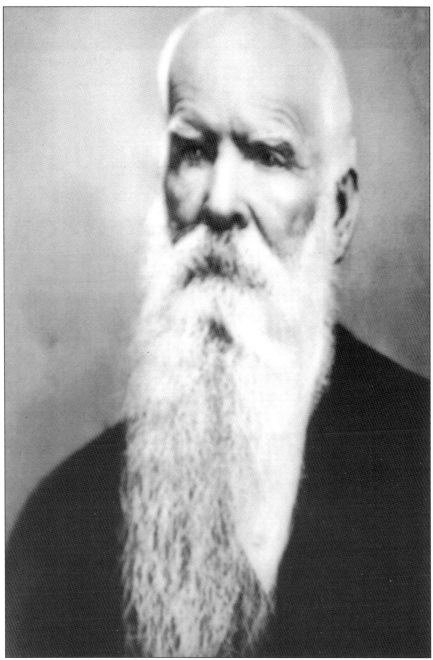

Robert Moderwell Sloan (1812–1905), the son of John and Mary Shields Sloan, was born in Lexington, Virginia, of Irish descent. Sloan arrived in Greensboro at age 13 with his uncle, Robert Moderwell, one of the town's early merchants. Sloan, also a merchant, was an agent for the Southern Express Company. It was during Sloan's term as mayor that the town of Greensboro became a city. He was such a good-hearted soul that he hated to raise taxes on the struggling townsfolk, even though the newly created city was in dire need with garbage problems, livestock roaming the streets freely, and the streets impassable with mud. Sloan ranked amongst the most beloved gentlemen of Greensboro in his time.

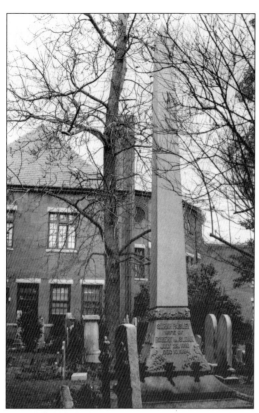

Sloan was affectionately called Uncle Bob. The words aunt and uncle in 19th-century Greensboro were commonly used to show endearment. Sloan married Sarah Jane Paisley (1816–1884) a former May Day queen and daughter of Rev. William Paisley, in 1836. Pictured is the Sloan obelisk. (RC.)

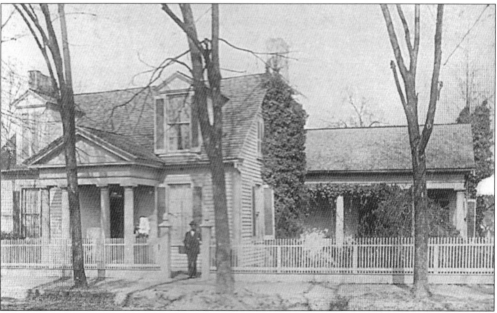

Shown is the home Sarah Sloan inherited from her father, Reverend Paisley. The house was built in 1820, supposedly with wood from the Guilford County Courthouse originally located in Martinsville. This home would provide shelter for the Paisley, Sloan, and Logan families for generations. The house has survived the passage of time and is located in Greensboro. (GPL.)

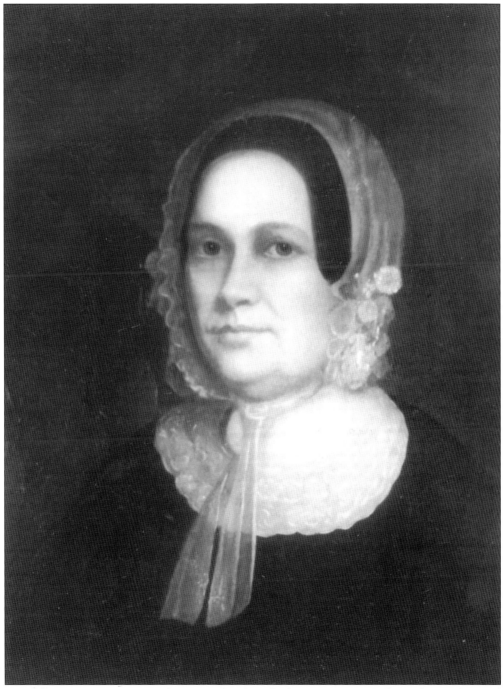

Celia Freeman Sutton Mebane (1803–1870) is described as a "consort" of John Mebane. This word was used to denote a spouse of one of elite status. Celia was a member of the First Presbyterian Church. Carved on the slab of her box tomb are the words "Her children rise up and call her blessed." (UNC.)

The box tombs of John Alexander and Celia Mebane are shown above. This type of gravestone appealed to the elite of society in 19th-century North Carolina. The signature of J. D. Couper of Norfolk is found on the lower right corner of Celia's box tomb. Signatures are often found on old gravestones on the lower right corner of the monument, though occasionally they are on the lower left, on the footstone, or on the side railing. Local artisans usually did not sign their work, as it was well known in the community.

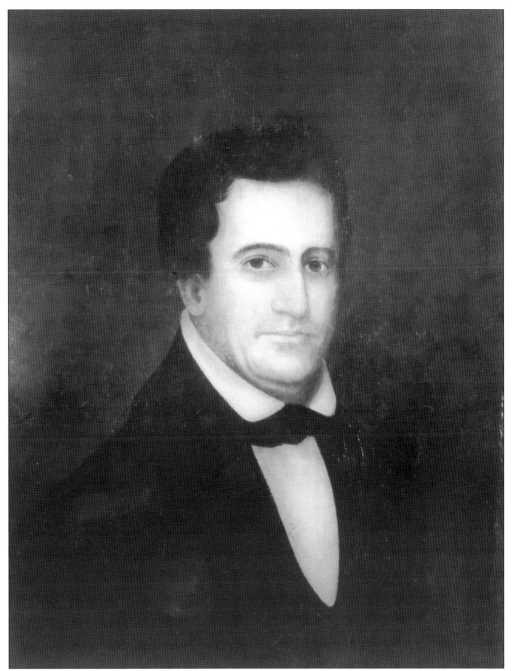

John Alexander Mebane (1790–1861) was an early leader in building the hamlet of Greensboro. He was active in progressing education and health and served as an early postman. He lays buried in a box tomb beside his wife, Celia. The inscription on his tomb is too worn to read. This image is reputed to be that of Mebane. (UNC.)

Remember the DEAD! TOMBS and MONUMENTS.

The undersigned respectfully informs his friends and the public at large, that he is now prepared to furnish all kinds of Monuments and Tombstones, of latest designs, with promptness, and at prices to suit the times.

Orders solicited and promptly filled.

☞All work west of Company Shops delivered on the railroad free of charge.

Samuel C. Robertson (1837–1903) beseeches the citizens to remember their dead in this advertisement in an 1869 *Patriot* newspaper. He mentions prices to suit the times. Greensboro was recovering from the financial losses of the Civil War. Money was scarce, and many a family had to wait to purchase grave markers for their loved ones. Andrew and Margaret Weatherly's identical monuments, shown on the right in the image below, are examples of Robertson's work in which his signature is readable.

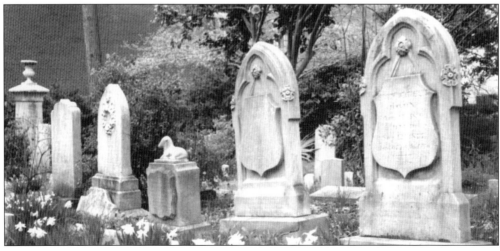

Robertson eventually left Charlotte to reside in Greensboro. One will find the Robertson family plot in the First Presbyterian Church Cemetery. Shown above is his gravestone. The ornate gravestone of Hazell (1872–1873), a son of Robertson and his wife, Leanna (1842–1885), is adorned with ivy. The motif depicts a hand with the index finger pointing upward, symbolizing a victory over death. His obituary in the *Patriot* reads "Earth counts a mortal less, Heaven an angel more." (RC.)

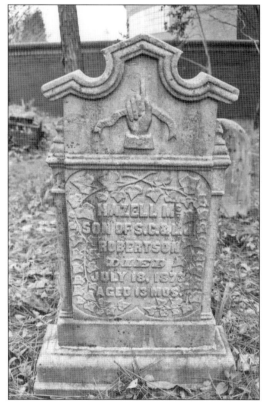

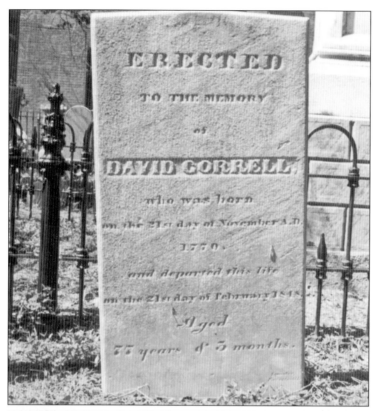

David Gorrell (1770–1848) is the son of Ralph Gorrell, who originally owned the land Greensboro is situated upon. His monument is signed "Lauder, Fayetteville." George Lauder's work often was simply signed "Lauder." In the early to mid-19th century, many communities did not have a resident stone carver. Lauder was an itinerant stone carver who traveled from town to town offering his services. A large number of gravestones in this cemetery bear his signature.

The monument of Clement Wright (1824–1865) is a work of art signed by Van Gunden and Young of Philadelphia. Clement's wife, Annette (1836–1903), is buried beside him with a similar monument. Clement died of disease shortly before the end of the American Civil War. Annette served the First Presbyterian Church as an organist. Carved on her monument are the words "Peace Perfect Peace." The phrase is from the Bible and is also a church hymn. The First Presbyterian Church Cemetery displays a wide array of stone carvers.

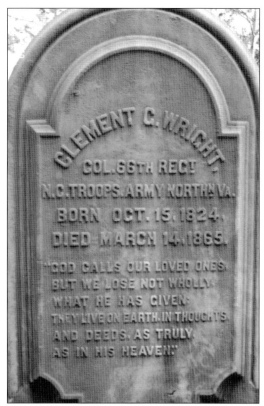

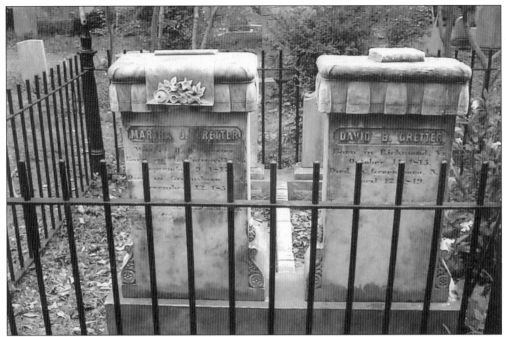

Shown are the ornate monuments of Martha J. (1815–1849) and David B. Gretter (1817–1850). By the 1870s, blueprints of monuments came into existence, thus enabling stone carvers to duplicate one another's work. These monuments are a design by Richard Wathan. Carved on Martha's monument are the words "Even so they also which sleep in Jesus will God bring with him." On David's marker are the words "Blessed are the dead which die in the Lord." Mourning motifs in the form of flowers adorn men's, women's, and children's gravestones.

Shown is the gravestone of John V. B. Wilkes (1855–1865) of Zanesville, Ohio. The use of initials was quite common in the 19th century. Several gravestones in the cemetery have initials as identifiers, and as a result, many of the deceased are now unknown. The signature of the stone carver, William Tiddy, is on the lower right.

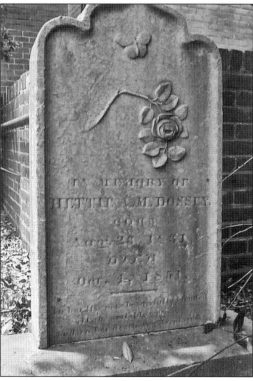

A butterfly adorns Hettie Dossey's (1831–1851) gravestone, symbolizing her metamorphosis from earthly life to heavenly life. Mourning symbolism found carved upon the tombstones include wreaths, flowers, willow trees, urns, palm fronds, open books, closed books, columns, rings, birds, hands, and funeral drapery. Symbols and wording carved into the monuments often have hidden meaning. Hettie Dossey's family is buried nearby. They were Methodist in their religious affiliation.

The beautiful urn and mourning drapery bearing the name of Mary is carved from a single piece of marble, thus lending insight into the talents of 19th-century stone carvers who created one-of-a-kind works of art with primitive chisels and hammers. Mary Virginia Lindsay (1834–1853) was the daughter of Jeduthun and Martha Lindsay. Mary's early death was a result of consumption. Carved on her stone are the words "Blessed are the pure at heart for they shall see God." Mary's gravestone is endangered and will eventually topple if preventative action is not taken. The holly tree is possibly one of the largest in North Carolina; thus, removing the tree is not a consideration. If Mary's monument is moved, it changes status from a grave marker to a memorial marker.

Carved on Nannie Morris's (1831–1852) monument is the weeping willow and urn, popular 19th-century symbols of mourning. Nannie was a member of the Methodist Episcopal church. Shown below is the pedestal monument of Esther Clemmons (1795–1857). On her gravestone is inscribed, "Sacred to the memory of our sister, Esther Clemmons, gone to the grave, but we do not deplore thee though sorrow and darkness encompass the tomb. The Savior has passed through its portals before thee and the lamp of his love is thy guide through the gloom. Thou art gone to the grave, but 'twere wrong to deplore thee when God was thy ransom, thy guardian and guide. He gave thee, and took thee, and he will restore thee, where death has no sting since the Savior has died." (RC.)

William Watkins (1841–1912) and his wife, Emily Stevenson Davies (1847–1878), share a blue granite headstone of a modern variety in the Davies family plot. Watkins served in the Civil War from the state of Virginia. Shown below is the monument of William Sterling and Dorinda Caroline Moore. Notice the carved M in the center of the monument. The Moore family was active in the First Presbyterian Church. William Moore earned the title "The Orphan's Friend" for his work with children. He was a storekeeper selling goods ranging from groceries to pianos. In 1878, William Moore was deeply distressed to learn that someone attempted to rob his store. He was a staunch supporter of prohibition.

Shown is the unique tree monument of Calvin Nicks and Isabella McConnel McAdoo. The tree symbolizes a life cut short by death. In 1849, a small pox outbreak in Greensboro struck the McAdoo family. The family in the city was recovering, but sadly, the family members in the country were seriously affected. This disease caused quite a panic in Greensboro and the surrounding communities. When it came time for court day in May of that year, the town was virtually empty for fear of the disease. Shown is the cross adorning William R. Walker's (1813–1855) monument. The cross is rarely used in the cemetery.

Shown is the monument of Elizabeth Kersey (1826–1920), wife of David Kersey (1811–1880). This monument is made from blue Vermont marble. The monument was marketed in the early 20th century in the Sears and Roebuck catalog. Inscribed on the stone are the words "As a wife devoted/ As a mother affectionate/ E'er friend and love." The top of the monument displays an open book motif with the words "God is Love."

The First Presbyterian Church Cemetery has many common fieldstones laying about the graveyard. The fieldstone pictured has a pointed edge. Early burials often were marked with wooden headstones that have long since disappeared. The use of rocks was quite common on graves of the poor and in country graveyards. The Fischer and Fowler families supposedly are interred in the First Presbyterian Church Cemetery without tombstones.

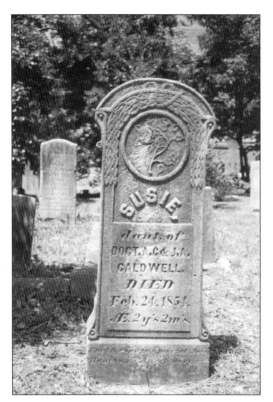

Shown are the gravestones of siblings Susie (two) and Jimmie (three), children of Dr. Andrew C. and Julia Ann Caldwell. The children died within days of one another in 1854 of scarlet fever. Carved on Susie's monument is the following: "Earth counts a mortal less/ Heaven an angel more." On Jimmie's matching monument is: "Not lost blest thought/ But gone before." Most of the monuments in this cemetery have settled through time and are tilted.

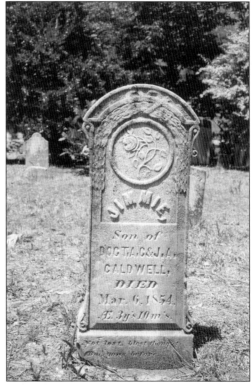

Charlotte and Mary Gorrell (1843–1867), beautiful belles of Greensboro, are shown above. They were the daughters of Ralph and Mary Gorrell. Mary is buried beside her family members in the First Presbyterian Church Cemetery, though Charlotte is not. Below are fragments and footstones of the deceased. It is not known today who these people are or where they are buried. Much history is lost in undocumented pictures and fractured gravestones. (Top: GDR.)

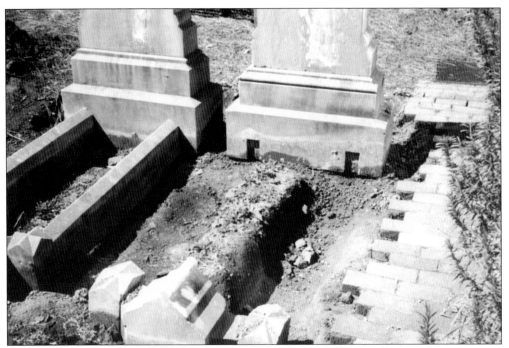

Restoration is painstakingly being performed in the cemetery. Shown is the work being done on the Lindsay side rails. This style of marker, with headboard, footboard, and side rails, is the most popular in the cemetery. The recently unearthed monument of Martha Lindsay awaits restoration. Notice the drooping flower motif.

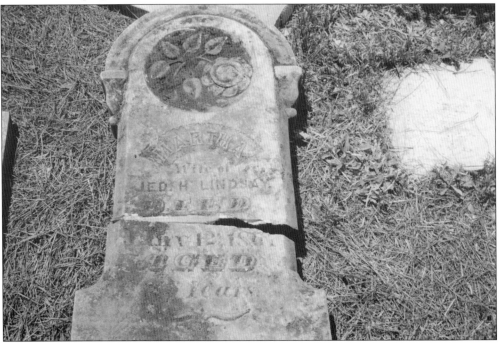

In the early spring, the First Presbyterian Church Cemetery is a virtual paradise of blooming flowers. Reference to flowers is an integral part of the cemetery from its origination to modern times. In the heat of the summer, the cemetery takes on a tropical atmosphere. At the memorial gate is a sign proclaiming that the First Presbyterian Church Cemetery is owned and maintained by First Presbyterian Church.

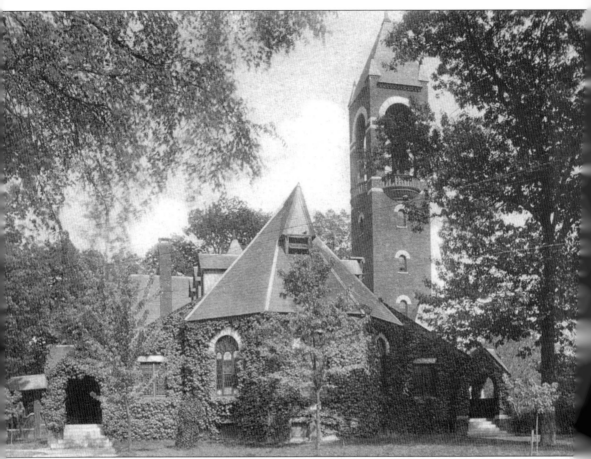

This 1907 postcard depicting the First Presbyterian Church covered in ivy is postmarked with a Benjamin Franklin 1¢ stamp. Franklin once said, "Show me your cemeteries and I will tell you what kind of people you have." The ivy depicted on gravestones in old cemeteries symbolizes immortality and a clinging to love ones who have gone before.

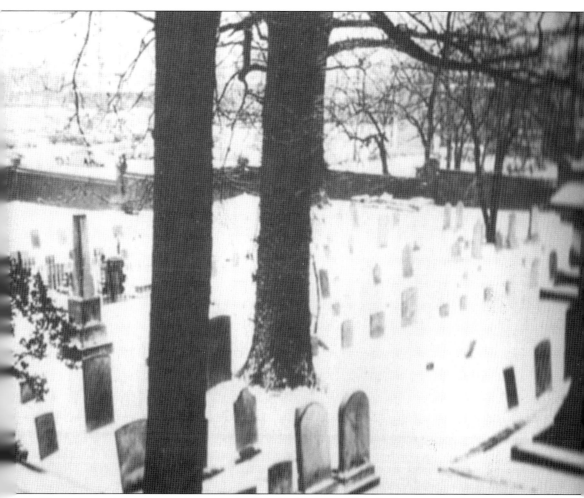

Many winters have come and gone in the First Presbyterian Church Cemetery, and many seasons have passed. The future will come quickly to the old cemetery, and all the flowers now living will fade. New generations of flowers throughout time will visit the old cemetery. Perhaps if one walks gently amongst the marble stones, one may be blessed with a special walk through time to a place called yesterday. (GHM.)

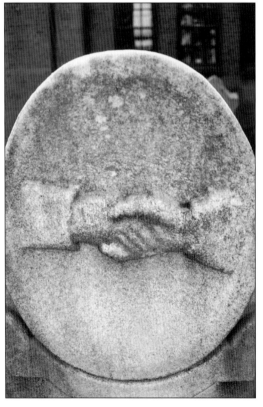

In 2008, the city of Greensboro will celebrate 200 years of existence. The pioneer First Presbyterian Church Cemetery will play a significant role in telling the stories of the early citizens who laid the foundation for the city of today. Due to the labors of many concerned citizens, the First Presbyterian Church Cemetery will exist another hundred years.

BIBLIOGRAPHY

Albright, James W., comp. *Greensboro 1808–1904: Facts, Figures, Traditions and Reminiscences.* 1904. Reprint, Salem, MA: Higginson Book Co.

Arnett, Ethel Stephens. *Confederate Guns Were Stacked Greensboro, North Carolina.* Greensboro, NC: Piedmont Press, 1965.

———. *Greensboro, North Carolina: The County Seat of Guilford.* Chapel Hill: UNC Press, 1955.

Ashe, Samuel A'Court, LL.D. *History of North Carolina Volume II from 1783 to 1925.* 1925. Reprinted, Spartanburg, SC: The Reprint Company, 1971.

Bridges, Earley Winfred. *Greensboro Lodge No. 76 AF&AM.* Staunton, VA: McClure Printing Co., 1951.

Caldwell, Bettie D., comp. *Founders and Builders of Greensboro, 1808–1908: Fifty Sketches.* Greensboro, NC: Jos. J. Stone and Company, 1925.

Caruthers, Rev. Eli W., D.D. *Revolutionary Incidents and Sketches of Character Chiefly in the Old North State.* Hayes & Zell Philadelphia: 1856. *The Old North State in 1776 Volumes I and II with Index,* Republished by the Guilford County Genealogical Society 1985.

Clark, Walter, ed. *Histories of the Several Regiments and Battalions from North Carolina in the Great War 1861–'65.* 1996. Reprint, Goldsboro, NC: Broadfoot Publishing Company.

First Presbyterian Church Archives.

Grant, Daniel Lindsey, ed. *Alumni History of the University of North Carolina 1795–1924.* Durham, NC: General Alumni Association of the University of North Carolina. Christian and King Printing Company, 1924.

Greensboro Daily Record.

Greensboro Patriot.

Greensboro Public Library Vertical Files.

Konkle, Burton A. *John Motley Morehead and the Development of North Carolina 1796–1866.* Philadelphia: William J. Campbell, 1922.

National Archives and Records Administration.

Rankin, Rev. S. M. *History of Buffalo Presbyterian Church and Her People.* Greensboro, NC: Jos. J. Stone and Co., 1934.

Simpson, John Wells. *History of the First Presbyterian Church of Greensboro, N.C., 1824–1945.*

Sloan, John A. *Reminiscences of the Guilford Grays, Co. B, 27th NC Regiment.* Washington, D.C.: R. O. Polkinhorn, 1883.

Stockard, Sallie W. *The History of Guilford County North Carolina.* Knoxville, TN: Gaut-Ogden Co., 1902.

ACROSS AMERICA, PEOPLE ARE DISCOVERING SOMETHING WONDERFUL. *THEIR HERITAGE.*

Arcadia Publishing is the leading local history publisher in the United States. With more than 3,000 titles in print and hundreds of new titles released every year, Arcadia has extensive specialized experience chronicling the history of communities and celebrating America's hidden stories, bringing to life the people, places, and events from the past. To discover the history of other communities across the nation, please visit:

www.arcadiapublishing.com

Customized search tools allow you to find regional history books about the town where you grew up, the cities where your friends and family live, the town where your parents met, or even that retirement spot you've been dreaming about.